Spirit OF THE SAN JUANS

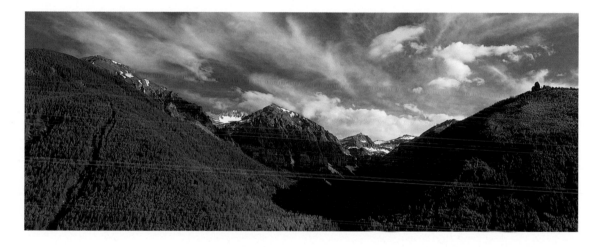

WESTERN REFLECTIONS, INC.
OURAY, COLORADO

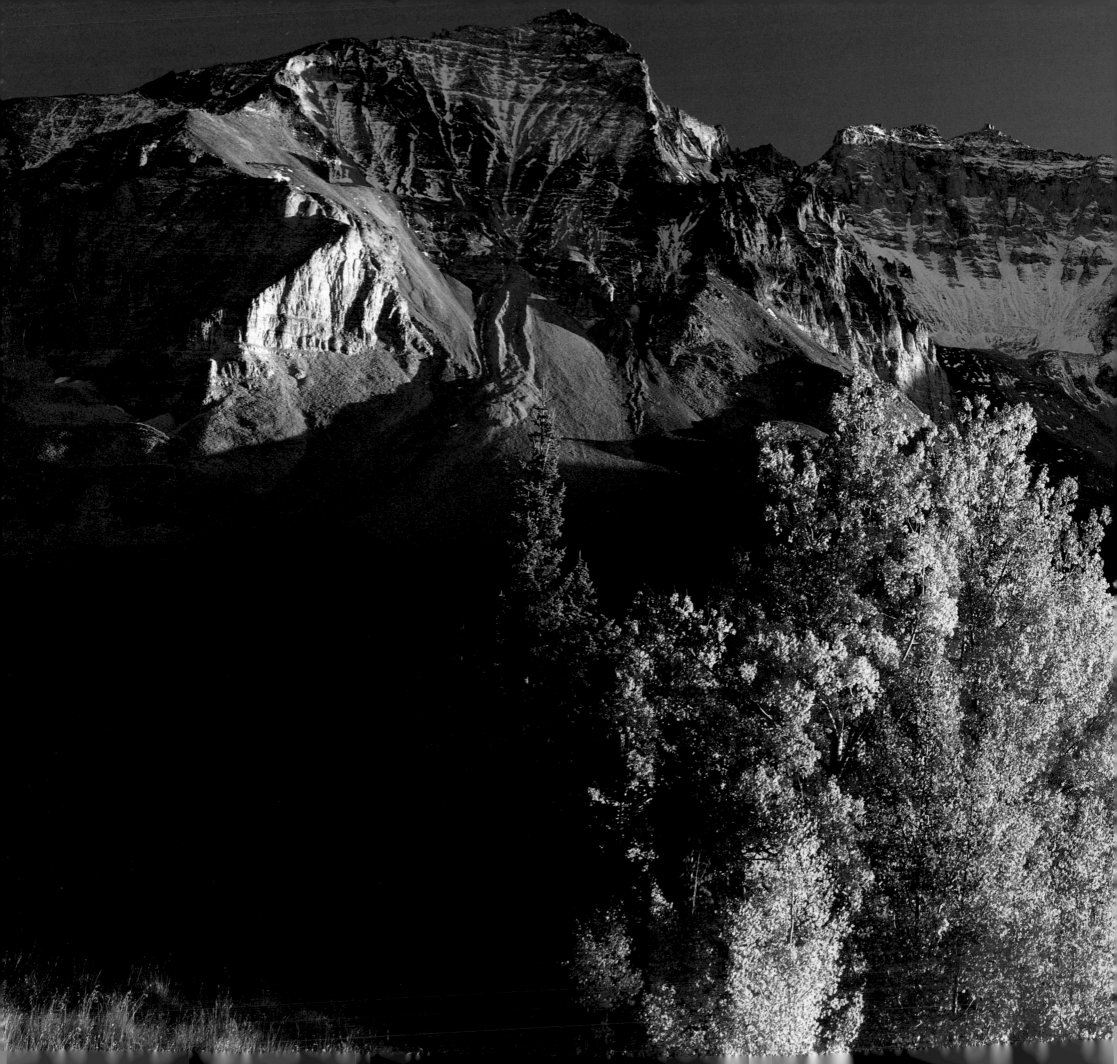

Spirit
OF THE SAN JUANS

PHOTOGRAPHY BY

KATHLEEN NORRIS COOK

To my mother, Una Marie Richoux Norris.

She always believed in me.

WESTERN REFLECTIONS, INC.
P.O. BOX 710
OURAY, COLORADO 81427
U.S.A.

FIRST PRINTING 1998
PRINTED IN THE UNITED STATES OF AMERICA
LIBRARY OF CONGRESS CATALOG CARD NO. 98-060195

ISBN 1-890437-10-7

JACKET DESIGN, BOOK DESIGN, TYPOGRAPHY:
PAT WILSON, COUNTRY GRAPHICS

INTRODUCTION BY P. DAVID SMITH

FIRST EDITION

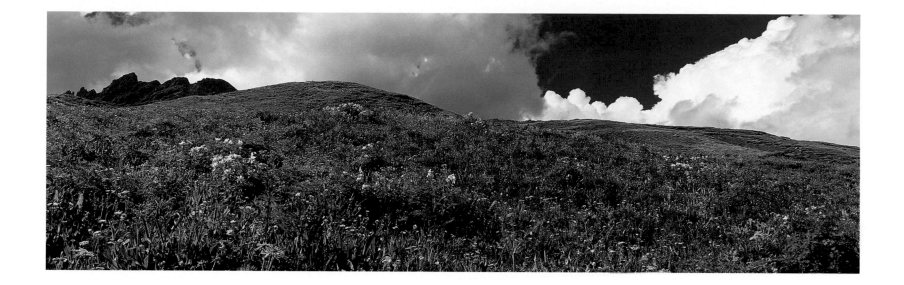

Contents

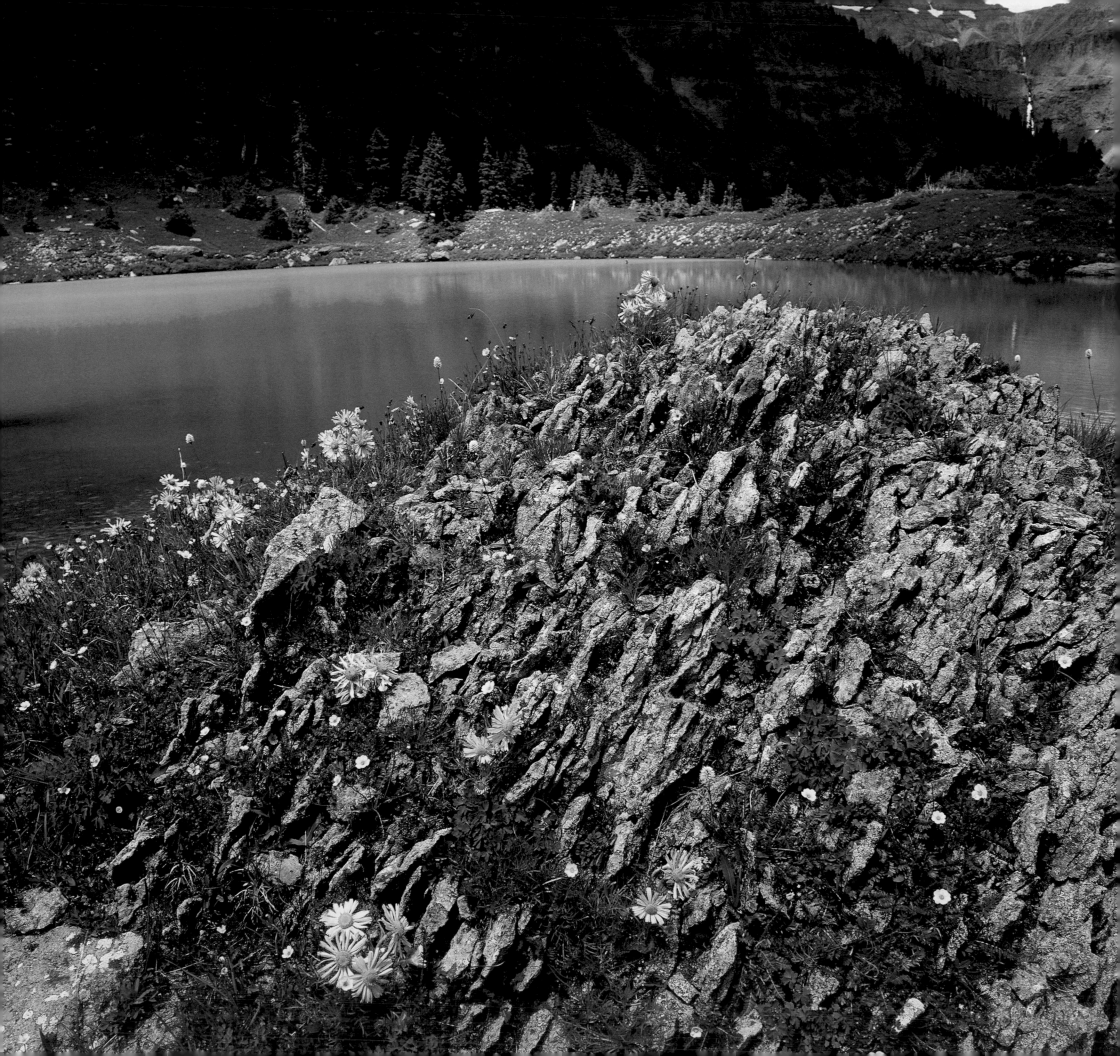

Introduction

"Shining Mountains" to the Ute Indians, the "Silver San Juans" to the prospector, "God's Country" to the visitor or simply "home" to the locals— the San Juan Range in southwestern Colorado is a harsh, challenging and rugged land of grand peaks, which contains some of the most precipitous, dangerous and wildly irregular mountains in the world. The 12,000 square miles encompassed by the San Juan Mountains collectively compose the highest area of elevation in the continental United States. Yet somehow this remarkable region possesses a spirit that captures the heart of all who come here. Those who visit, play, work or are fortunate enough to live in this magical place find it inspiring, uplifting and gratifying. Those who leave are always drawn to return—at least in their hearts—for there is something here for which the soul yearns. The *Spirit of the San Juans* with its stunning photographs portrays that spirit.

The San Juan Mountains, which are unquestionably among the most impressive and beautiful in the world, extend over an area larger than several states. The amazing history of the San Juans rivals that of any other region in the West. Most visitors to the area take home a suitcase full of snapshots in a vain attempt to capture the beauty that abounds. In fact, the true essence of the San Juans is quite difficult to grasp. Nevertheless, Kathleen Norris Cook has accomplished just that with her award-winning photographs. Cook has presented her vision of the western San Juans, in an exceptional collection which captures the spirit of both the mountains and a few of the local inhabitants who live in and have come to love these mountains. With her remarkable photographs, she explains that which cannot be put into words and what most have failed to convey in pictures. You will travel with her through the western San Juans from the ranching town of Ridgway to charming Ouray—the "Gem of the Rockies," on to the sportsman's paradise of Lake City, over high mountain passes to the Old West town of Silverton, through the mountains and down canyons into Durango, and finally over to spectacular Telluride, playground for the rich and famous. Kathleen Norris Cook has captured moments, mountains, and mysteries in her marvelous photographs of this breath-taking area—an area with an impressive history to match.

How did this wonderful region come to be? Fire and ice actually made the San Juan Mountains. Millions of years ago volcanoes caused a huge dome to rise 24,000 feet high. In places, the earth shifted causing huge cracks which pushed and lowered the surface so much that the earth's crust literally stood on end. In some sections as many as nineteen layers of the earth's geologic formations exposed as much as 26,000 feet of crust. Most of our indomitable peaks were then carved out of the huge land mass by slow-moving but powerful glaciers (some of which were around as recently as 10,000 years ago.)

Because of its large elevation differential, the San Juan Range is now a region that includes almost every temperate zone found in the United States—from arid, desert climes to high mountain tundra usually found only in the arctic. Every thousand feet of increased elevation is similar to traveling hundreds of miles north at sea level. The San Juans are far enough south that prevalent plant life is also determined by exposure to the sun. A north-facing slope is much wetter and colder than a south-facing slope. Vegetation therefore varies in a seemingly random pattern from clumps of juniper and pinion through thick aspen groves and evergreen forests to the fragile mosses and lichens of the alpine zone.

The Continental Divide runs through the middle of the San Juans, making it the origin of many of the large rivers of the west including the famous Rio Grande. Unlike settlers in the East, explorers didn't come into these mountains via the rushing, roaring rivers. Rather every mile of road in the San Juans was built at a tremendous cost in terms of money, labor and sometimes even lives. Ironically, the very remoteness and raggedness of the mountains has helped preserve the San Juans from the crushing onslaught of humanity sometimes known as "civilization" but which has spoiled so many beautiful spots in America. Many localities in the San Juans are so remote and difficult to cross that they have never been developed and have, therefore, joined our nation's small list of wilderness areas.

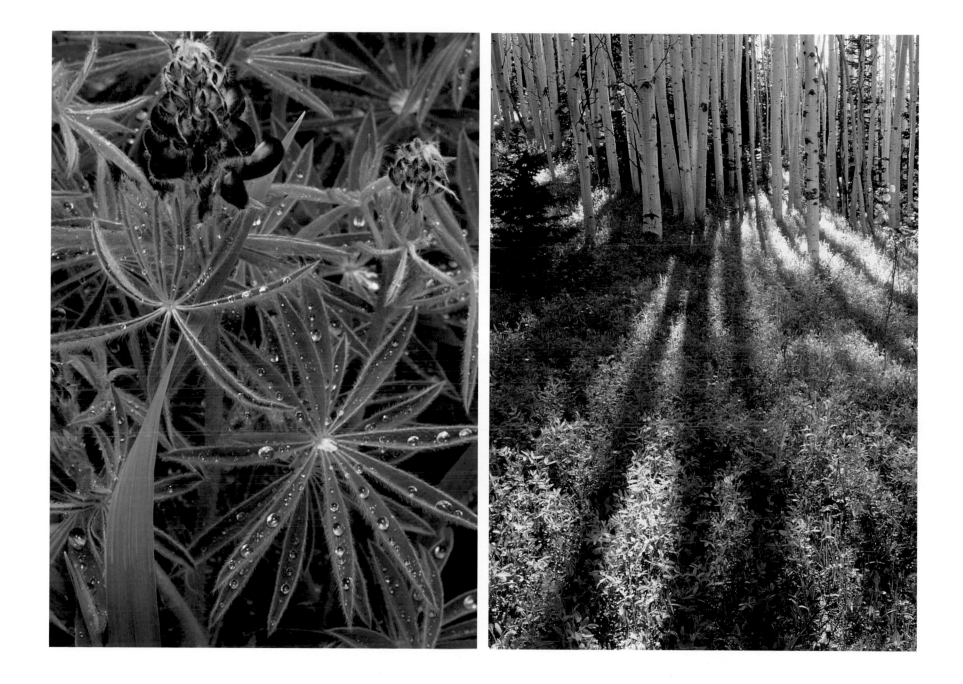

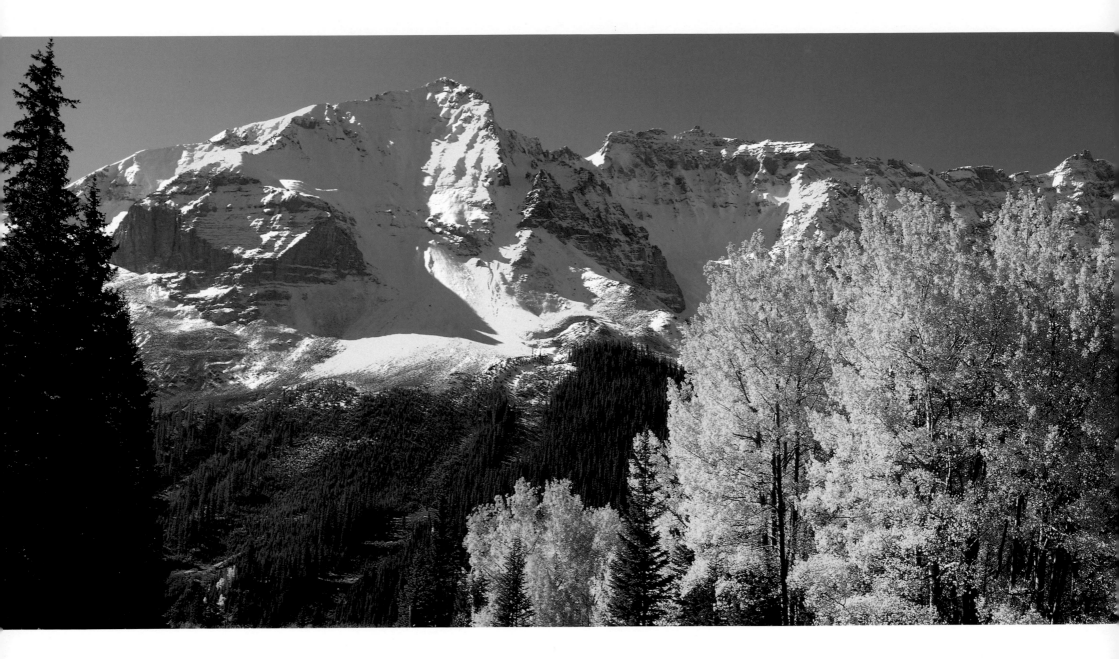

SPIRIT OF THE SAN JUANS

ten

In a land of craggy contrasts, the inhabitants of the San Juans have mirrored those contradictions. Humans first set eyes on the San Juans some 6,000 to 8,000 years ago. Remains of the Clovis, Folsom, Freemont and then Anasazi cultures reveal that they often ventured far into these mountains, although they built their homes only at the fringes. About the same time that the Anasazi left (approximately 1300 A. D.), the Ute Indians moved into what they called the "Shining Mountains." The imposing and harsh San Juans rewarded the nomadic Utes with a carefree, idyllic lifestyle. Although they used the high mountains only during the summer while on hunting and foraging trips, their legends and names for the local features show that they greatly loved the beauty of the San Juans and spent considerable time soaking in its sacred hot springs. In fact, the Utes believed that the heartbeat of Mother Earth herself could be heard by placing one's ear on a special rock on Uncompahgre Peak. The Utes protected their beloved mountains ferociously. Plains Indians, such as the Arapaho and Sioux, would often venture into other mountains of present-day Colorado, but seldom, if ever, did they dare journey into the San Juans. The Tabeguache band of Utes came to call the San Juans their home, although any of the other Ute tribes were welcome. The Tabeguache grew to be the largest and most powerful of all seven of the Ute tribes, and Chief Ouray of the Tabeguache was the first and only overall leader of the Ute bands.

Spanish explorers were in the San Juans by 1600. Very few written records of their presence exist since only "official" expeditions of the crown were allowed in unexplored Spanish territory and those were required to pay one-fifth of all their acquisitions to the king's treasury. Don Juan Mirade Rivera and Fathers Escalante and Dominguez were leaders of the few expeditions actually chartered. The friars passed through the San Juans the same summer that the Declaration of Independence was signed. We know that the Spanish were present in some numbers by what they left behind—Spanish coins, armor, weapons and the many Spanish names given the features of the region. It is from the Spanish that the San Juans got its name. "San Juan" is Spanish for Saint John and was probably a reference to John the Baptist, a rugged individual who wandered in the wilderness for most of his life. The San Juan region has more than its fair share of lost Spanish gold mine legends; the very earliest Americans found ancient equipment for mining and milling gold and silver, and there were long-abandoned tunnels that sometimes went deep into the mountains—all of which shows the considerable amount of time and effort expended by the Spanish in search of precious metals.

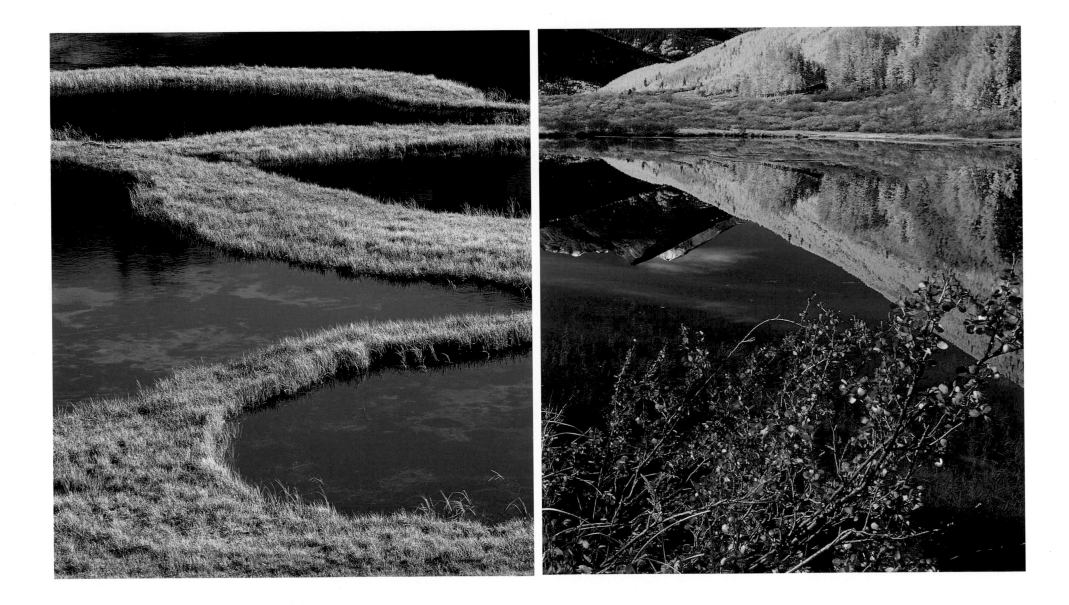

By the 1830s American trappers were attracted to the San Juans by the numerous streams teeming with beaver. The local Utes were initially friendly and more than willing to help the unfamiliar trappers who came into their homeland. The first prospectors appeared in the San Juans in 1848, but they quickly passed through on their way to the California gold rush. Explorers John C. Freemont in 1848 and John W. Gunnison in 1853 both journeyed through these mountains leading official United States expeditions which were looking for a plausible railroad route to California. Freemont called the San Juans "the highest, most rugged, most impracticable and inaccessible in the Rocky Mountains." When gold was discovered in 1858 at Clear Creek, near present-day Denver, over 50,000 prospectors rushed in to what later became Colorado Territory. When it was clear that there was not nearly enough gold on the eastern slope of the Rockies, many of the hopefuls ended up prospecting on the western slope in the San Juans.

By 1870 the San Juans were swarming with settlers even though the land was still in the heart of the Ute reservation. No one seemed to care that only a few years earlier the United States government had solemnly promised the Utes that all others would stay off their land "as long as the grass shall grow." Washington did, in fact, send soldiers to keep prospectors off the land. The Utes resisted the invasion, but Americans continued to flood in. The San Juans were finally ceded to the United States when the government offered to find Chief Ouray's lost son in exchange for the "Silver San Juans." By 1881 the Utes had lost this land forever.

Even though it was prospecting and mining that brought early-day settlers to the San Juans, they immediately recognized the awesome grandeur of these mountains. Many men worked twelve hours a day, seven days a week yet they found time for relaxation. The miners and their families occasionally enjoyed hiking, picking wildflowers, hunting, fishing and picnicking as well as soaking in the hot springs. C. L. Hall, a San Juan geologist, wrote in 1894: "No greater diversity of natural resources did the Almighty ever plant in an equal area.... Perennial streams, as pure as crystal, come dancing down from eternal snow banks.... Men partake of the nature of the section of the country that they inhabit and if they are here they become strong mentally and physically as this region is rugged and grand."

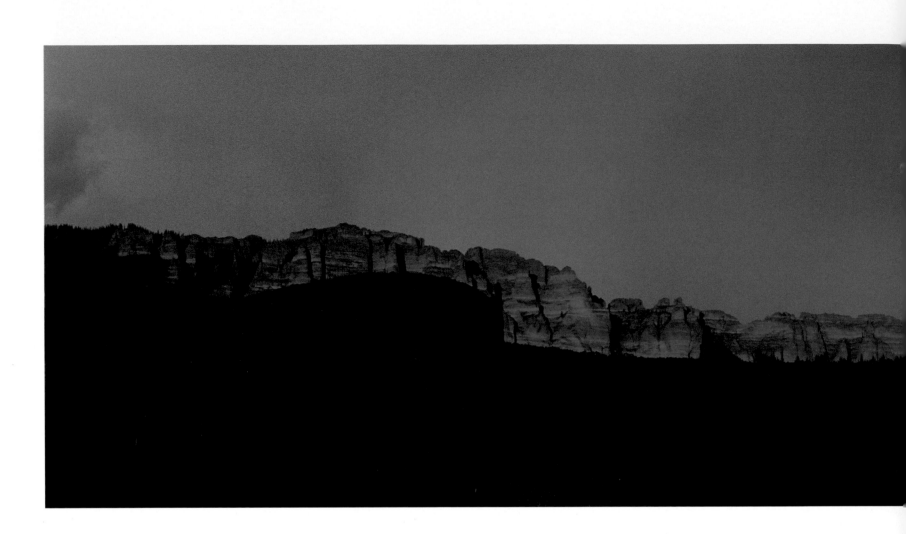

Those who looked for precious minerals were the first to attempt to spend the winter in the dangerous high country and many an early-day prospector paid the ultimate price because he underestimated the power of a San Juan winter. The miners soon learned that all supplies had to be brought in during the summer as travel slowed to a standstill during the long winters when the heavy snows often built up to twenty feet deep. More frightening were the deadly avalanches that could sweep down the mountains at any time. The harsh, cold winters and man's desire to inhabit the mountains year-round culminated in the epic quest of man versus nature. As in most instances, nature won. The miners learned to live with the harsh elements and the rugged land rather than to fight it. The environment honed and sharpened the miners like fine steel on a good knife. A local priest, J.J. Gibbons, wrote in 1890 that "the lofty peaks by which (the miner) is surrounded make him a man of broad views and noble ideas."

Duane Smith, noted San Juan historian, has done an excellent job of describing why the San Juans originally attracted so many people despite the hardships they endured. "They believed. Believed they did— that the San Juans would be their salvation. They had faith that allowed them to stand against an

uncompassionate environment and compete with their fellow man, to persevere against the long odds, to build a life where everything conspired against them." That attitude continues into the present. The people of the San Juans have a relationship with their land. They are connected both by the current environment and by the rich history of their surroundings.

Although mining was the main economy of the San Juans until the 1960s, it is an industry that has always gone hand-in-hand, with tourism. Even the earliest prospectors noted the stunning beauty and it was not long before awestruck visitors were attracted. Travel writers from far-off places were sending glowing accounts of the unimagined grandeur of the San Juans back to New York and as far away as England and Spain. Ernest Ingersoll, a writer for *Harper's Weekly*, wrote in 1885 as he approached the San Juans at night: "The mountains ahead came into plainer view; we...saw that the rounded outlines of the bluffs on each side were changing to abrupt walls, and trending inward, and then the hush of night and the quiet of weariness turned our thoughts to meditative channels." The mountains continue to attract and inspire all types of artists—the poet, potter, painter and photographer to name just a few.

Enthusiastic accounts of rich discoveries of gold and silver in the San Juans caused a huge influx of people in the 1880s. (There are fewer people living here today than were here one hundred years ago.) Silverton and Ouray were two of the largest towns in all of Colorado. The question soon arose as to how to feed so many people in a land that can grow few crops. With the advent of irrigation, it was discovered that vegetables could be grown in adjoining valleys. The first cow herds had arrived in the San Juans even before the white man. They were used to feed the Ute Indians who were starving to death since the vast influx of prospectors had killed off the wild game. Cattle, sheep, goats and fine horses were found to thrive on the high altitude grass. The true American cowboy and the authentic Basque sheepherder can still be found in the San Juans, although land is now so expensive that only the very rich or those who have been here for generations can afford to be ranchers.

During the 1960s tourism began to overtake mining as the main attraction of the San Juans. Although a sharp rise in metal prices could again set off another frenzy of prospecting activity, mining has since ceased to be economically viable. Passengers have replaced the freight and ore that had been hauled through the Animas Canyon for eighty years. Tourists discovering the magnificent scenery of a true wilderness area are now riding the train from Durango to Silverton. Purgatory and Telluride ski areas have become popular destination ski resorts. Jeeping over the high mountain passes has also become a popular summertime activity. Exploring ghost towns, climbing mountains and back-country backpacking are all enjoyed in an area accentuated by mining relics that lie strewn over the mountains. The continued influx of tourists into "God's Country" has led to a steady stream of new residents which, in turn, endangers the very beauty that attracted the extra population in the first place.

This magnificent and rugged land continues to form impressive and independent individuals. Just as the mountains themselves, small town values and relationships tend to alter ever so slowly. None of the distractions and changes of city life seem to exist in the San Juans; the mind, therefore, turns to enjoyment of the simpler but perhaps more meaningful things in life—nature, family and the arts, as examples. Time must be spread out when there are elements over which one simply has no control. When it is impossible to even get out of the driveway until after the snow plow arrives, frustration eventually wanes and there is time to think, enjoy one's family and be constantly reminded of life's beauty. The San Juans both isolate and protect from the outside world. People tend to feel safer and more secure as they become self-sufficient and do chores like cutting wood, erecting a rock wall or even building a house. There is plenty of time and room here to be alone and to get to know oneself. While solitude is available to all, most residents also learn that it is necessary for them to depend upon each other and to help their neighbors in time of need.

One factor, however, remains constant—the mountains. Perhaps the most beautiful mountains in the world—the awesome San Juan Mountains which form the people who live here and delight the visitors who only pass through. Inspiring mountains that have molded and continue to mold the inhabitants. A proud spirit that still lingers—the Spirit of the San Juans.

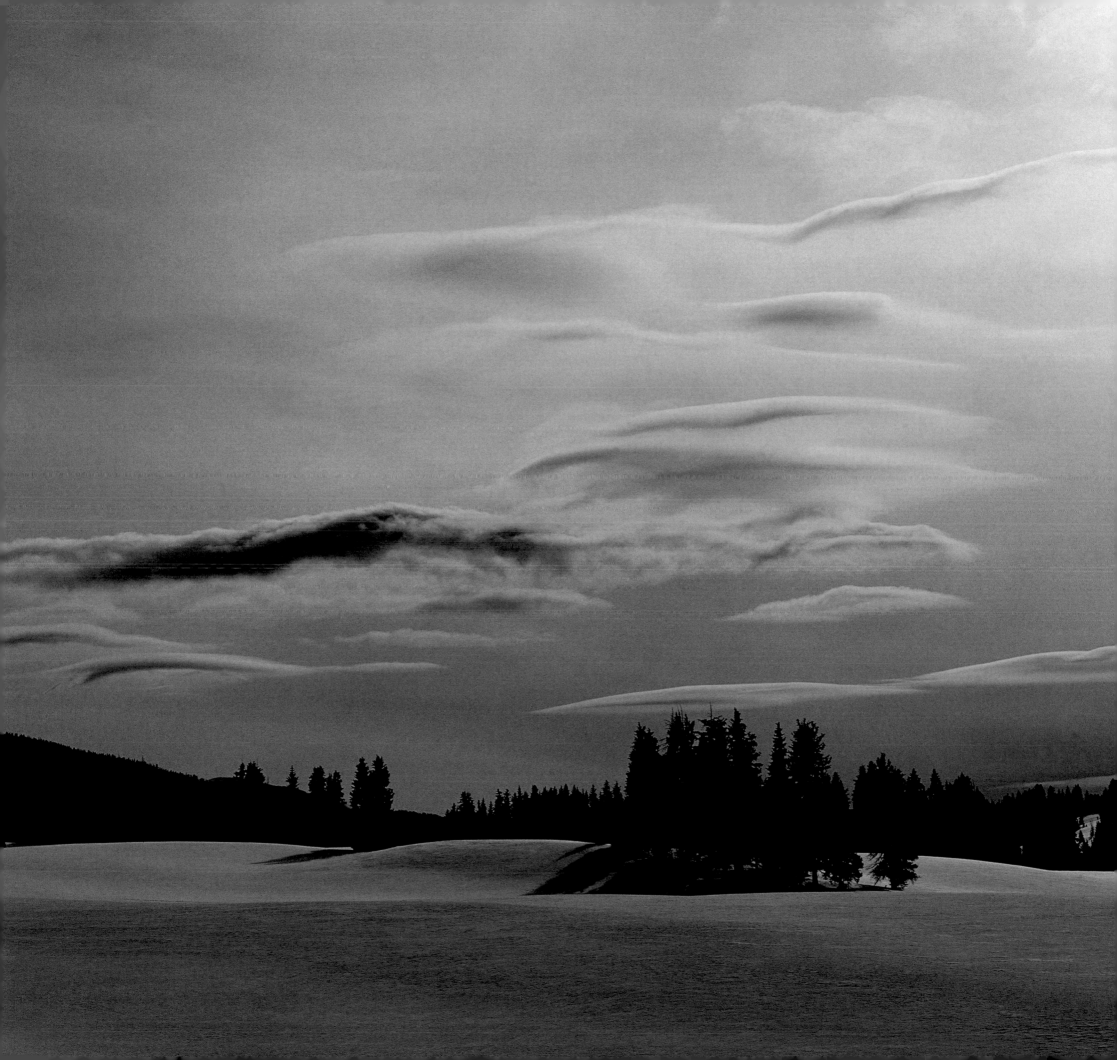

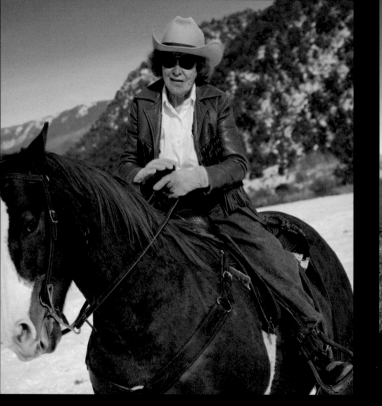

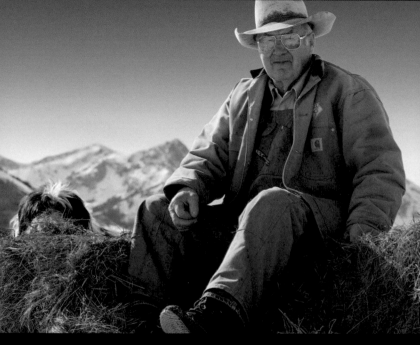

ESTHER LEWIS; GENE ADAMS

...ither Lewis has lived most all of her eighty-seven years near Ridgway, Colorado. She and her husband were married for thirty-five years. They operated a ranch during all that time. "We grew up together. We had a partnership. We had a very enjoyable life." ∽ Esther still drives cattle. "I get yearling steers in the spring months and sell them late in the fall. I get the profit from the gain on them during that period of time. I've averaged 350 to 400 pounds and even 500 pounds of weight gain in some cases. We do our serious house cleaning in the winter. We always neglect it during the summer because we are trying to get the steers out of the oak brush. We usually have quite a battle getting them down to civilization." ∽ "I wouldn't want to live anywhere else in the world. I have never seen a more beautiful area. I really don't know how to express this, but this place has about everything to offer for ranch life. I've been a rancher all my life except for taking time out for an education. My brand is bar open AF. It is an old territorial brand that belonged to my father-in-law. There has been a lot of changes over the years; but, well, we have to go along with progress—whatever brings in the most tax money and value. I love to travel up into these mighty peaks on a hot summer day and feel the coolness, the tranquil feeling, a feeling of peacefulness and serenity. This is home."

Gene Adams was born in the western part of San Miguel County and grew up in the eastern end. "I worked my father's dairy and we ran range cattle and sheep. In 1946 I became the youngest elected county commissioner in the state. I was commissioner for eighteen years. I owned the area that is now the Ski Ranches in Telluride. At the time I sold it I made big dollars, but it would only be pennies compared to what you could get for it today. When I knew Telluride, it was a little mining town. I never anticipated it would grow like it did." ∽ After he sold his ranch, Gene moved to near Ridgway and managed the Loraine Harney ranch for her sister Marie Scott. "We adjoin Ralph Lauren to the west and Wolf Ranches to the east. I'm right in the middle of multi-millionaires, but the beautiful part of it is that they are not developers. My ranch is a working ranch. We get started here about 6:00 a.m. cooking biscuits on the old wood stove. I have sour dough going—I've had it going for about thirty years. Then in the winter we start feeding the cows about 7:00 a.m. In the summer there's irrigating. We put up roughly 15,000 bails of hay this fall. It's a never-ending job on the ranch." ∽ "I've been all over the western part of the United States. There is nothing that compares to the western side of the San Juans. However, twenty years ago I could look out my window and there wasn't a light on the edge of Log Hill, and now it looks like a Christmas tree at night. They keep building everyday. I like it the way it used to be, but there is a trend toward development, so I guess I just need to live with it."

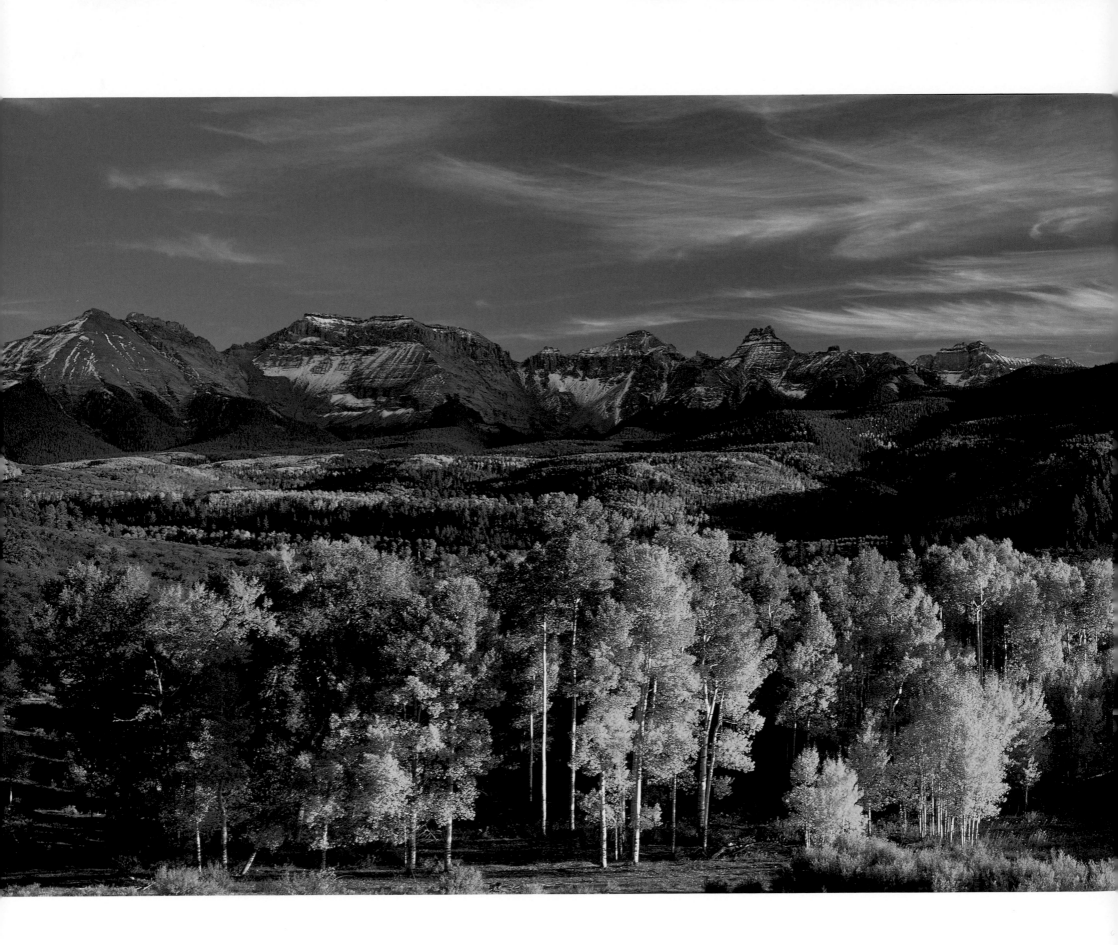

SPIRIT OF THE SAN JUANS

twenty

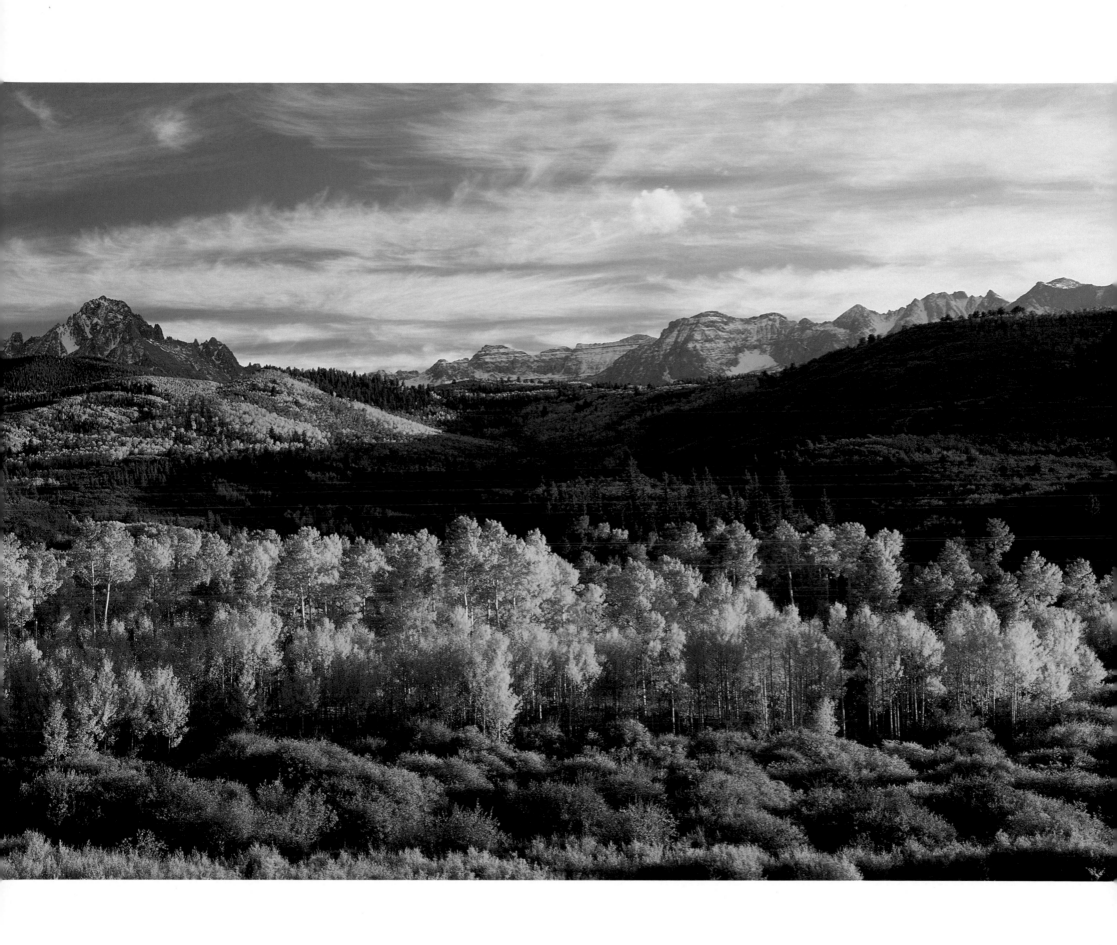

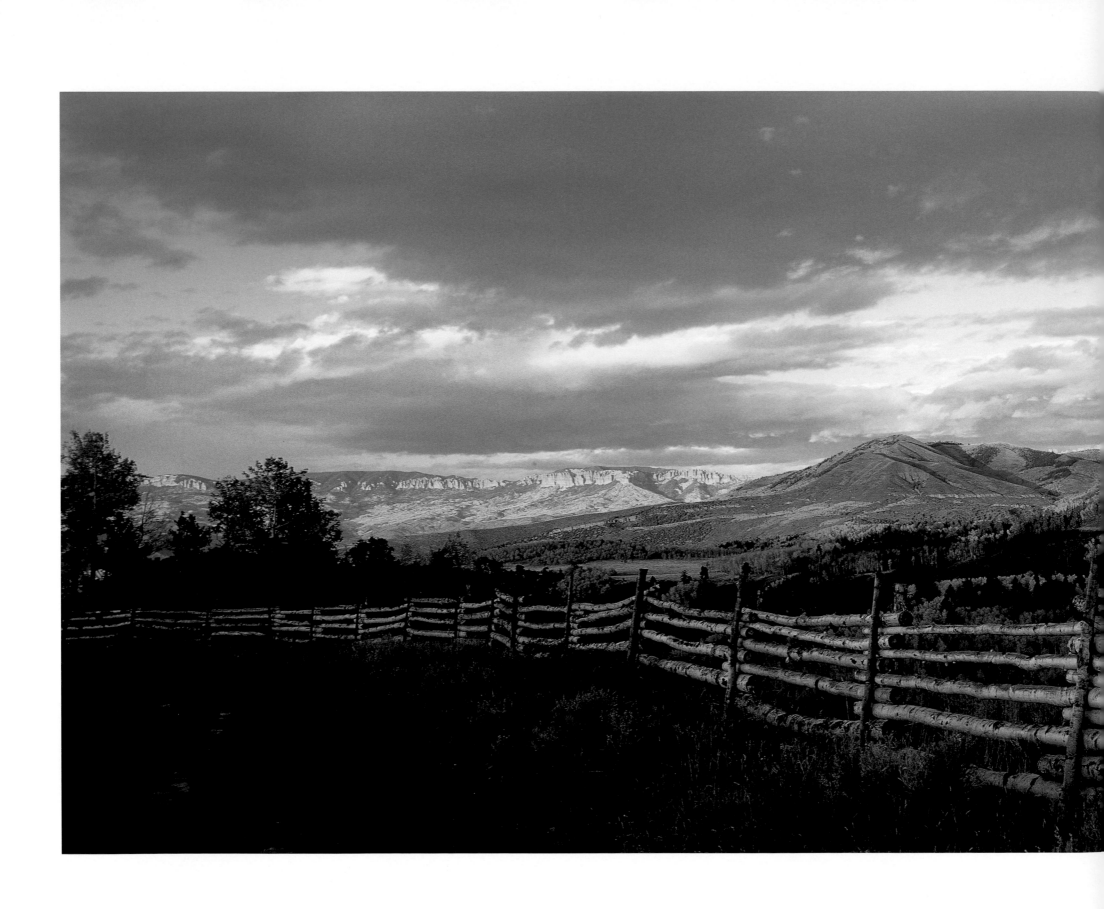

SPIRIT OF THE SAN JUANS

twenty-two

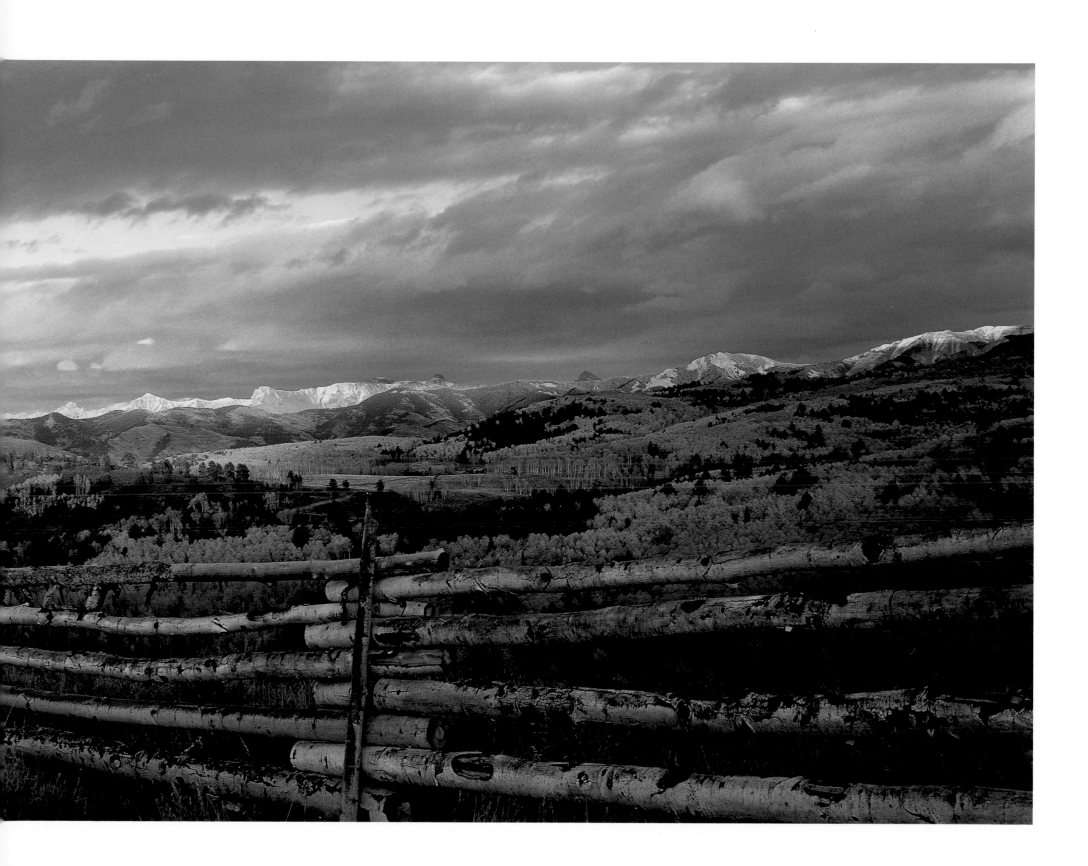

The earth,

the sun and stars, the universe itself,

and the charming variety of the seasons,

all demonstrate the existence of Divinity.

—P<small>LATO</small>

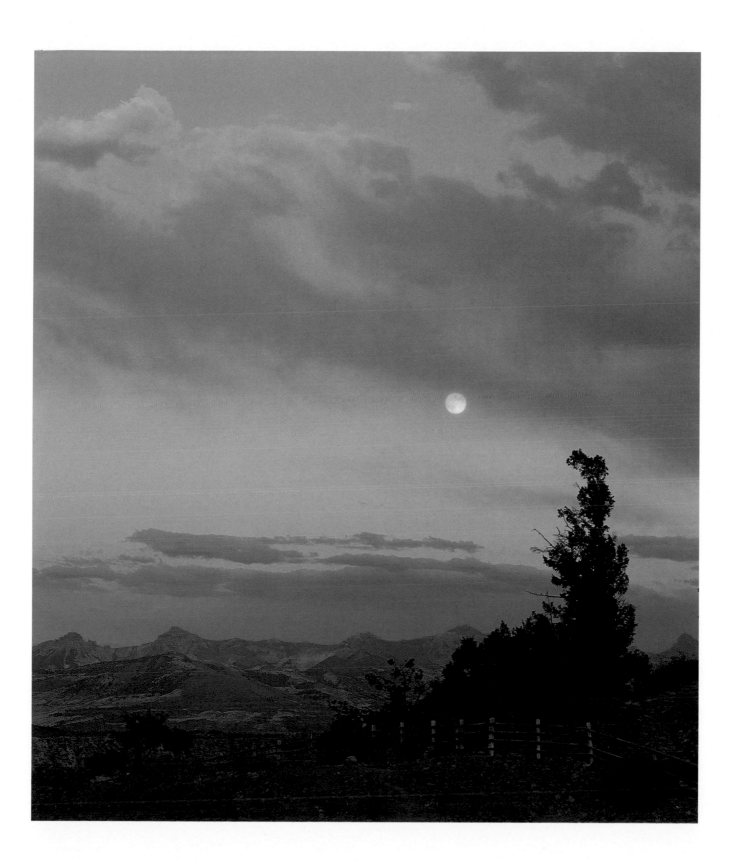

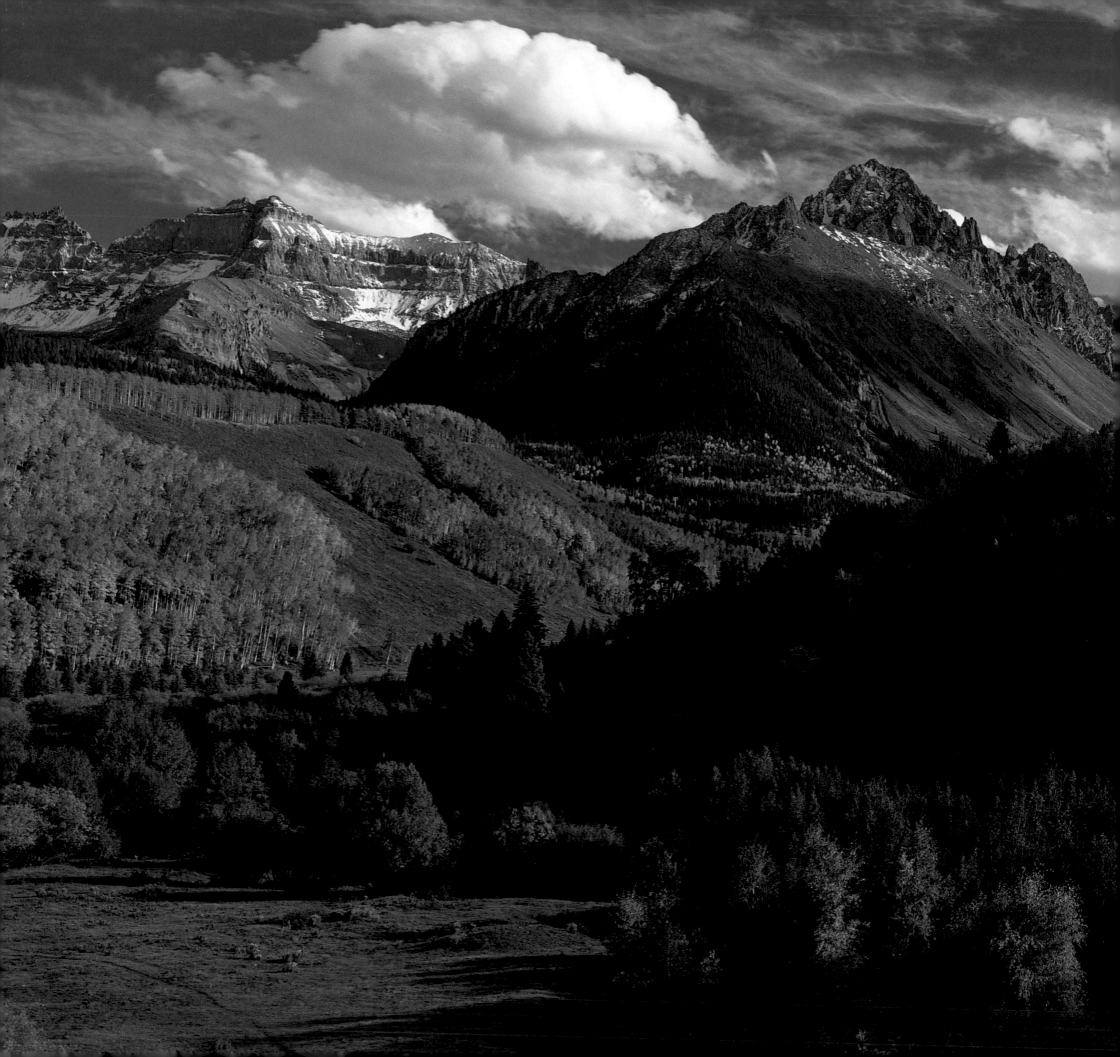

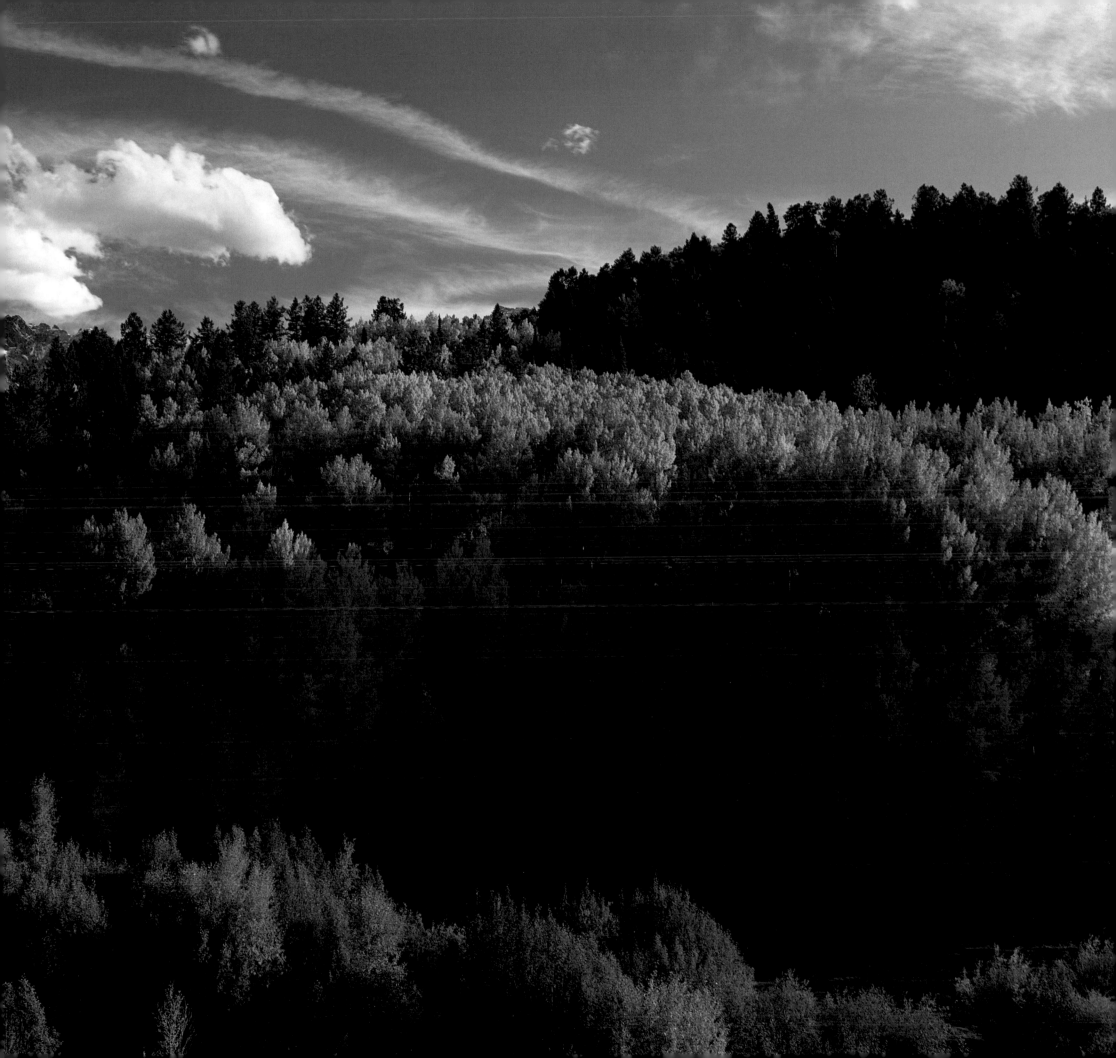

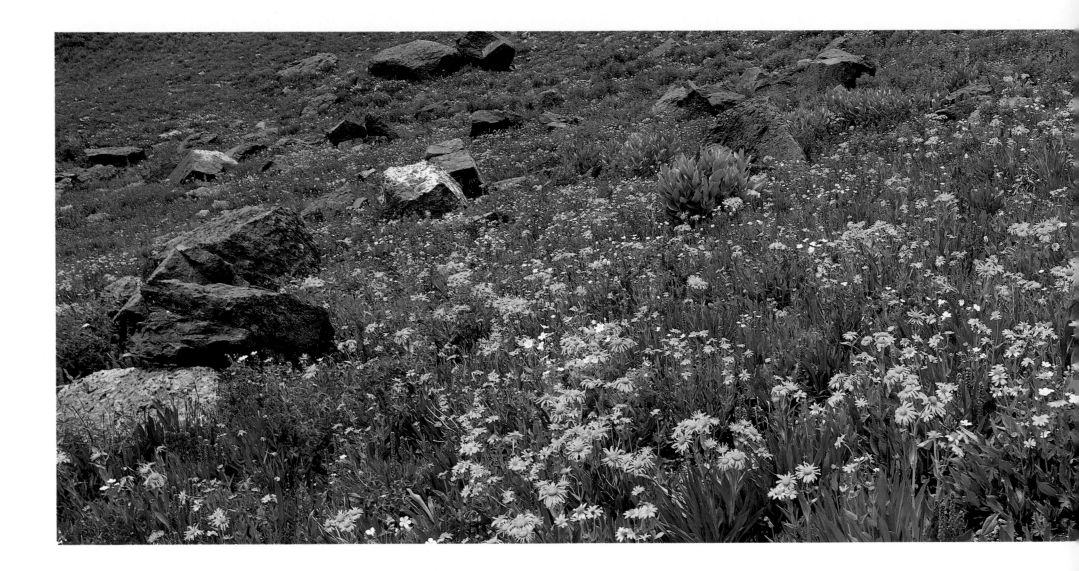

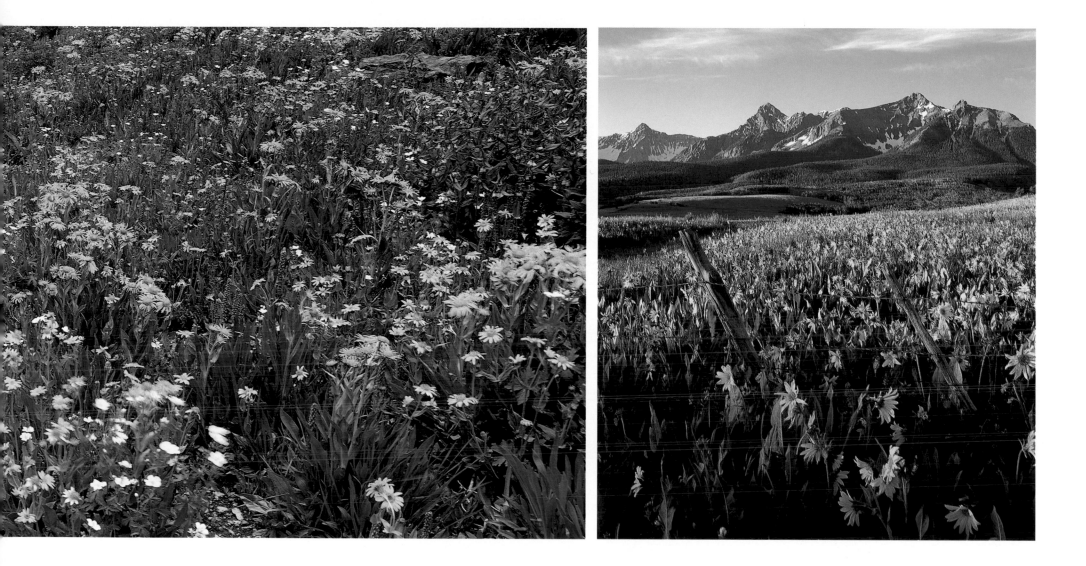

Love
all God's creation,

the whole and every grain of sand in it.

Love every leaf, every ray of God's light.

—Fyodor Dostoyevsky

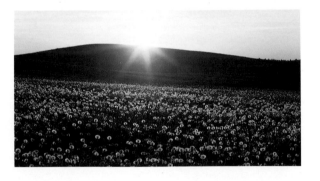

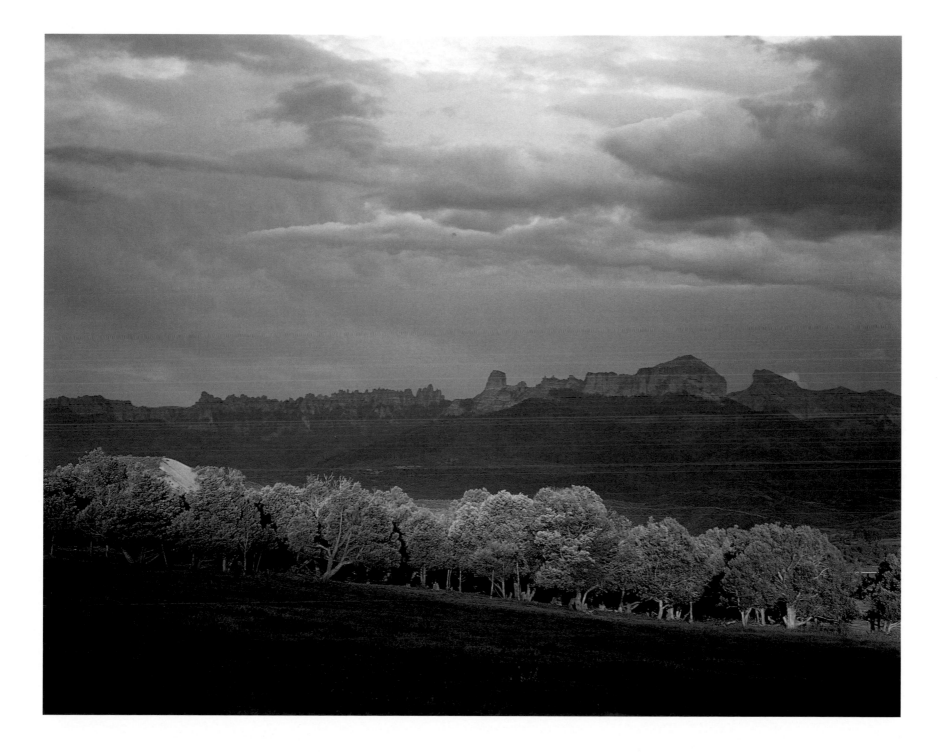

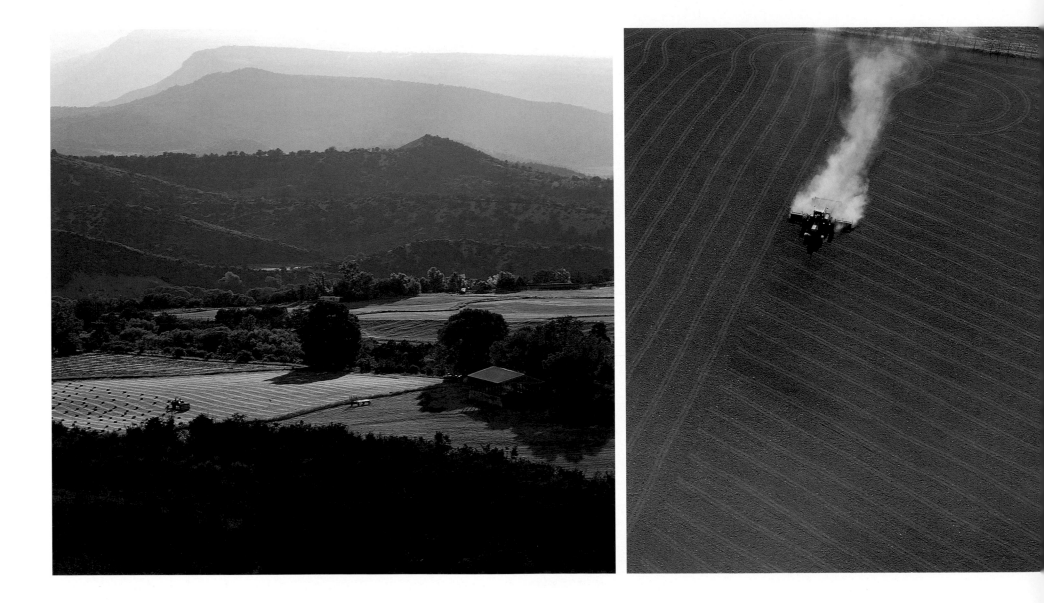

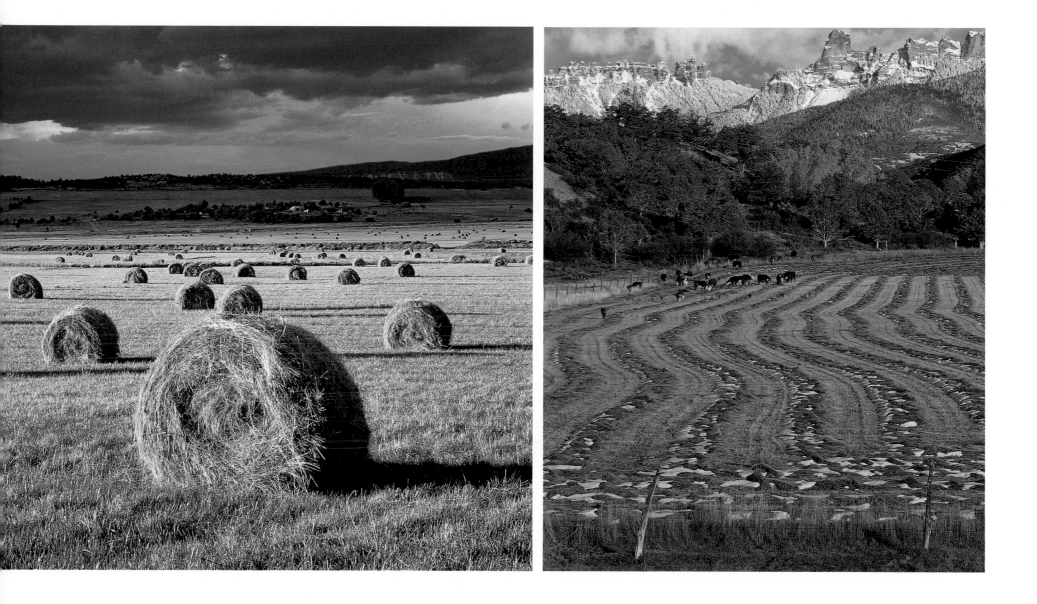

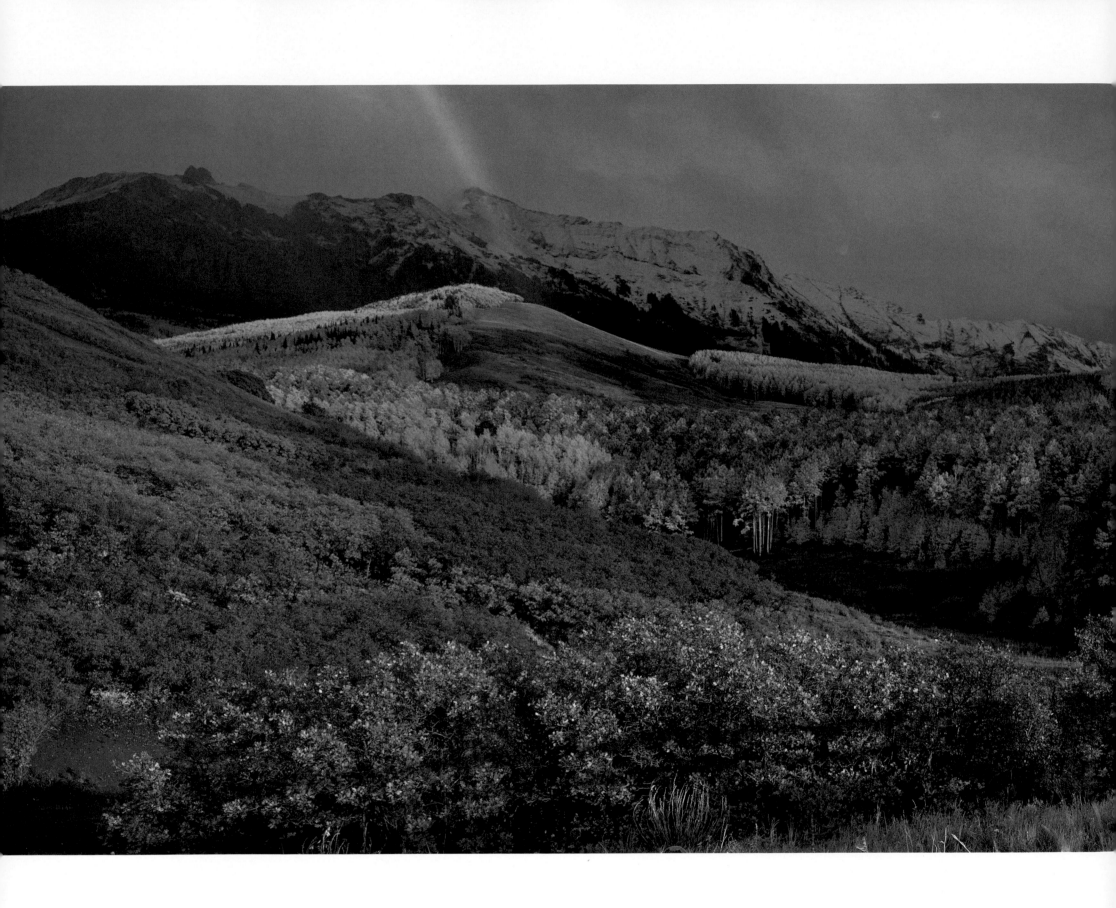

SPIRIT OF THE SAN JUANS

thirty-four

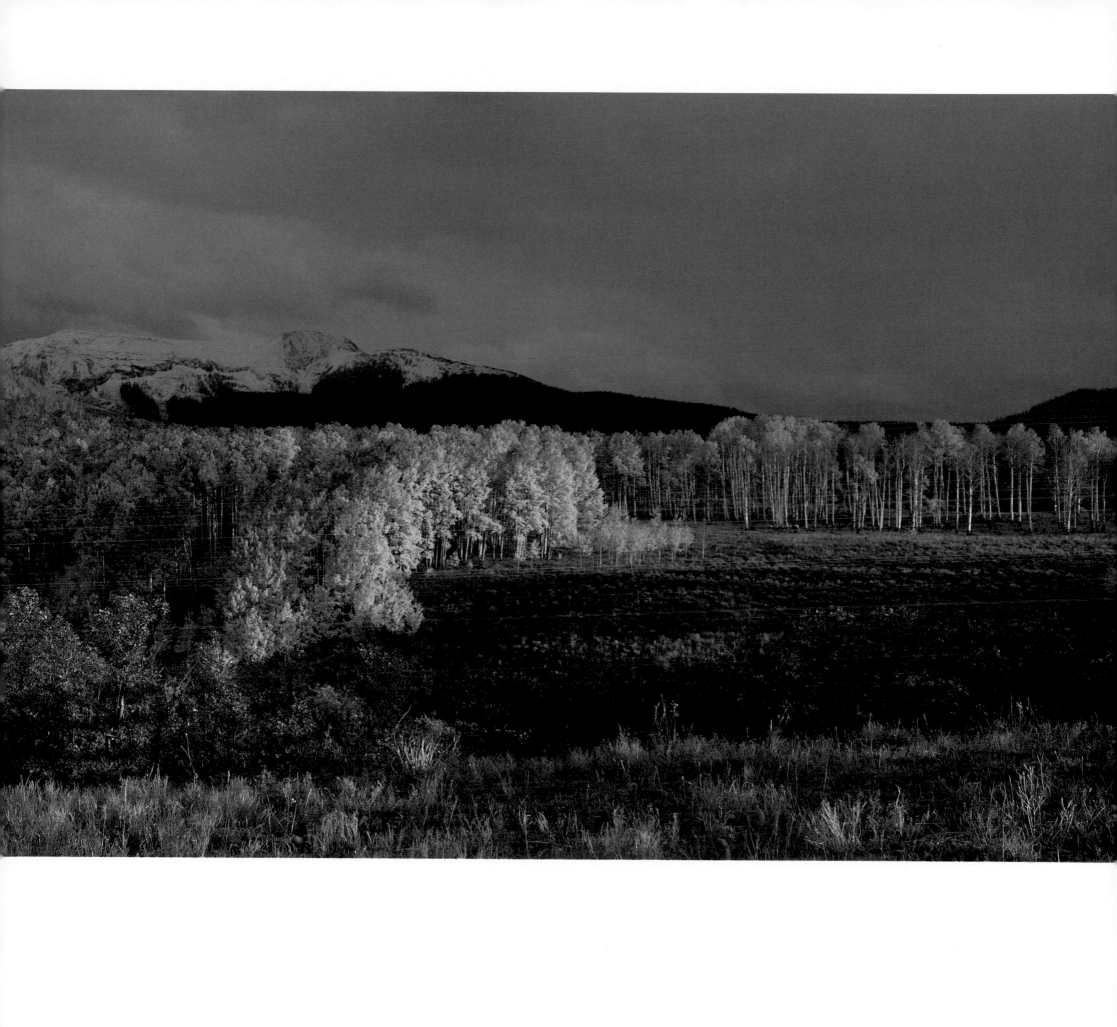

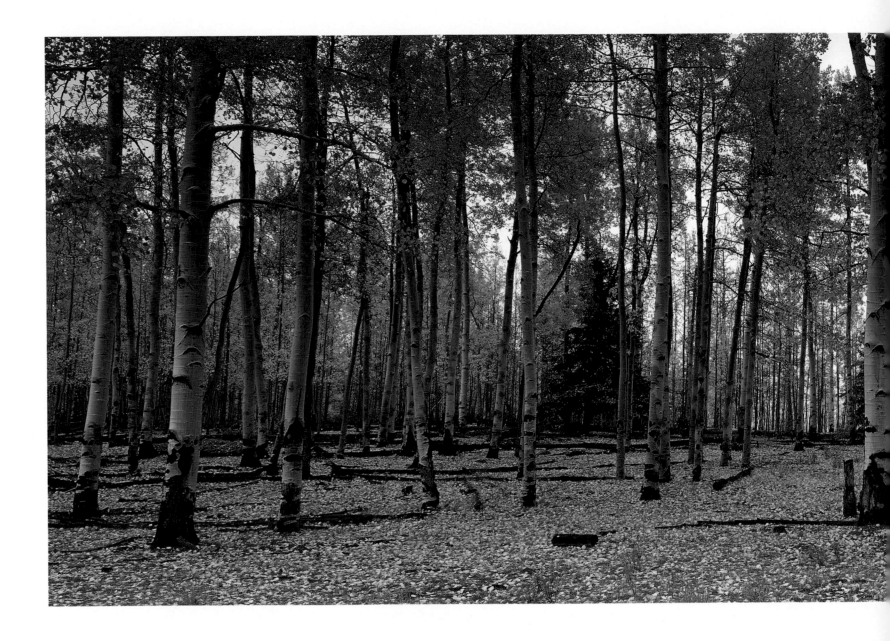

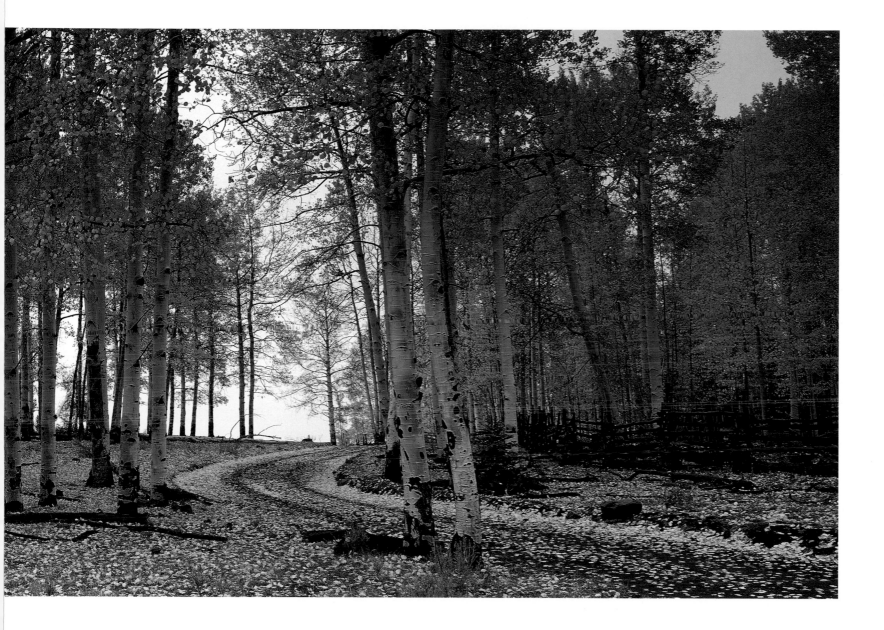

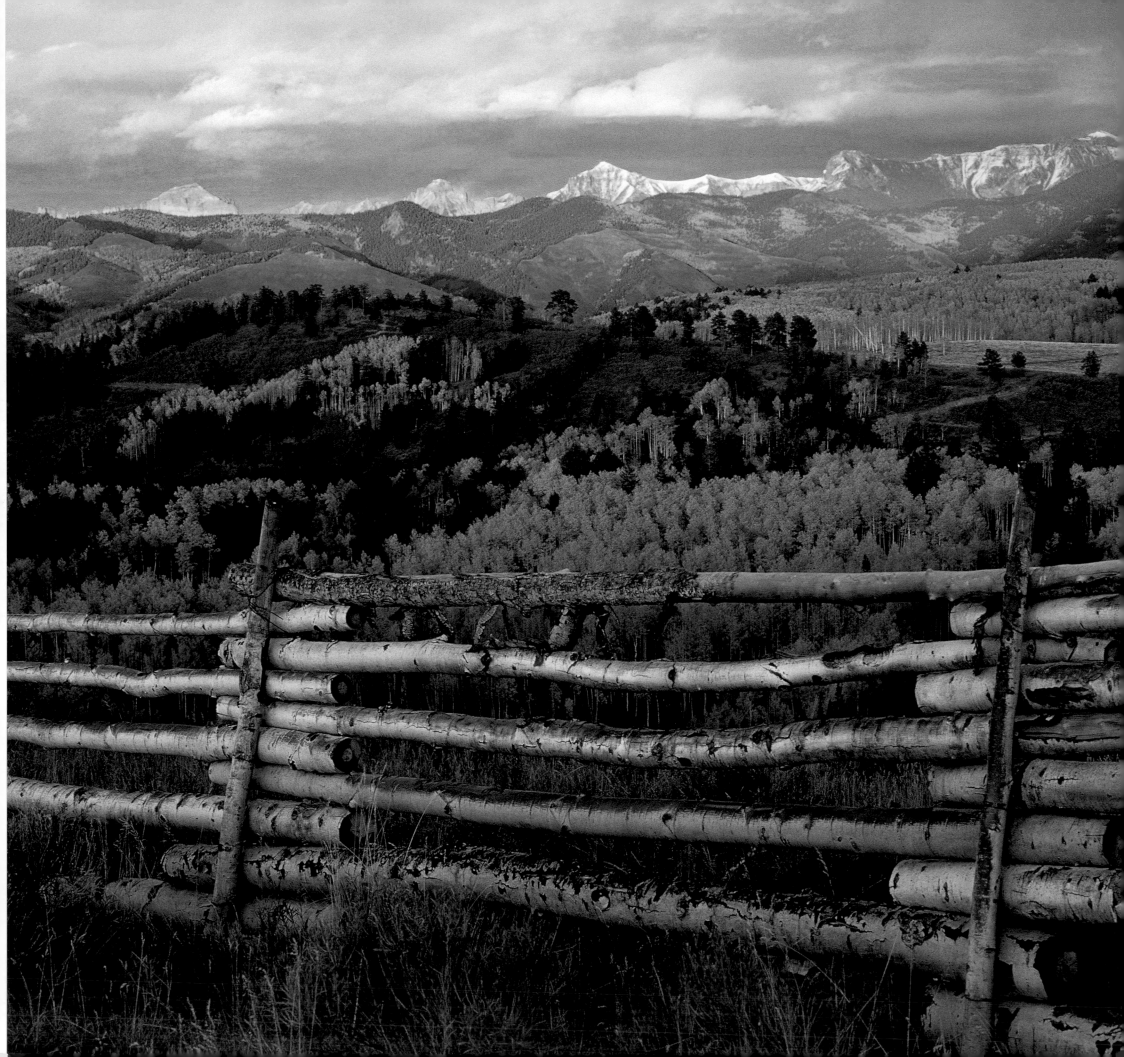

Let children walk with nature,

let them see the beautiful blendings and communions

of death and life, their joyous inseparable unity,

as taught in woods and meadows,

plains and mountains and streams of our blessed star,

and they will learn that death is stingless indeed,

and as beautiful as life, and that the grave has no victory,

for it never fights. All is divine harmony.

—JOHN MUIR

BERNICE SWIFT AND ROGER HENN; BARBARA SPENCER

Roger Henn and Bernice Henn Swift were born in Ouray, Colorado, moved away for much of their adult lives and then returned upon retirement. Their father served for a while as the school's principal, but later went into partnership in the Cascade Grocery. Roger and Bernice remember their childhood with great fondness. "We had such a wonderful playground with all these mountains to go hike, climb and play around in. Our family liked to picnic. Father was a naturalist, so we learned the names of all the flowers, insects and rocks." ⌁"In the winter everyone put their cars in the garage on blocks and they were left there until spring. Everyone used horses and sleds. They would cut ice down in the valley or at Black Lake, load it on the train, pull it up to Ouray, and pack it with sawdust at the ice house. It would last all summer long and was used to fill refrigerator cars when they were picking cherries and fruits in the Montrose area." ⌁"Our mother was very active in the Women's Club. That was the group of people who were considered the society in town. That's all gone now. Everyone in town is equal. It's a good change. If you don't want to live here, you simply move away. It doesn't matter if you were born here or whether you just moved here. You are here because you want to be here."

Barbara Spencer was born in Rico, Colorado, in 1916, but she has lived most of her life in Ouray. Mining decidedly runs in her blood. Her father was a mining engineer, her husband a miner and prospector and her son is still in mining. "My dad was an agent for Evelyn Walsh McLean at the Hidden Treasure Mine above the Upper Camp Bird. Members of my family still do assessment work on unpatented claims for the Walsh family heirs. My dad always took pride that he could be involved with mining since it is a primary source of bringing wealth to a nation." ⌁"It was wonderful to be here growing up and watching the ore wagons going out and coming in. Some people say how awful it must be to work in the mines. Well, farming wasn't any cinch either. Sometimes the farmers would come up and work in the mines in the wintertime and then work their fields in the summer. That gave them cash in case the crops failed. There should be regulations to protect the environment, but I get a little irritated when someone tells me that mining is ruining the environment. I hope their shoestrings break." ⌁"What I like about these mountains is the security. We're protected in this bowl in Ouray. The mountains are beautiful—the different colors, lights and shadows. The romance of the different mines and the people who did the mining, and the names of the mines and the money that came out of the ground—it's all good. Even though Ouray is eight months winter and four months of company, I just pull these mountains around my shoulders and sit here in comfort. I feel I'm home."

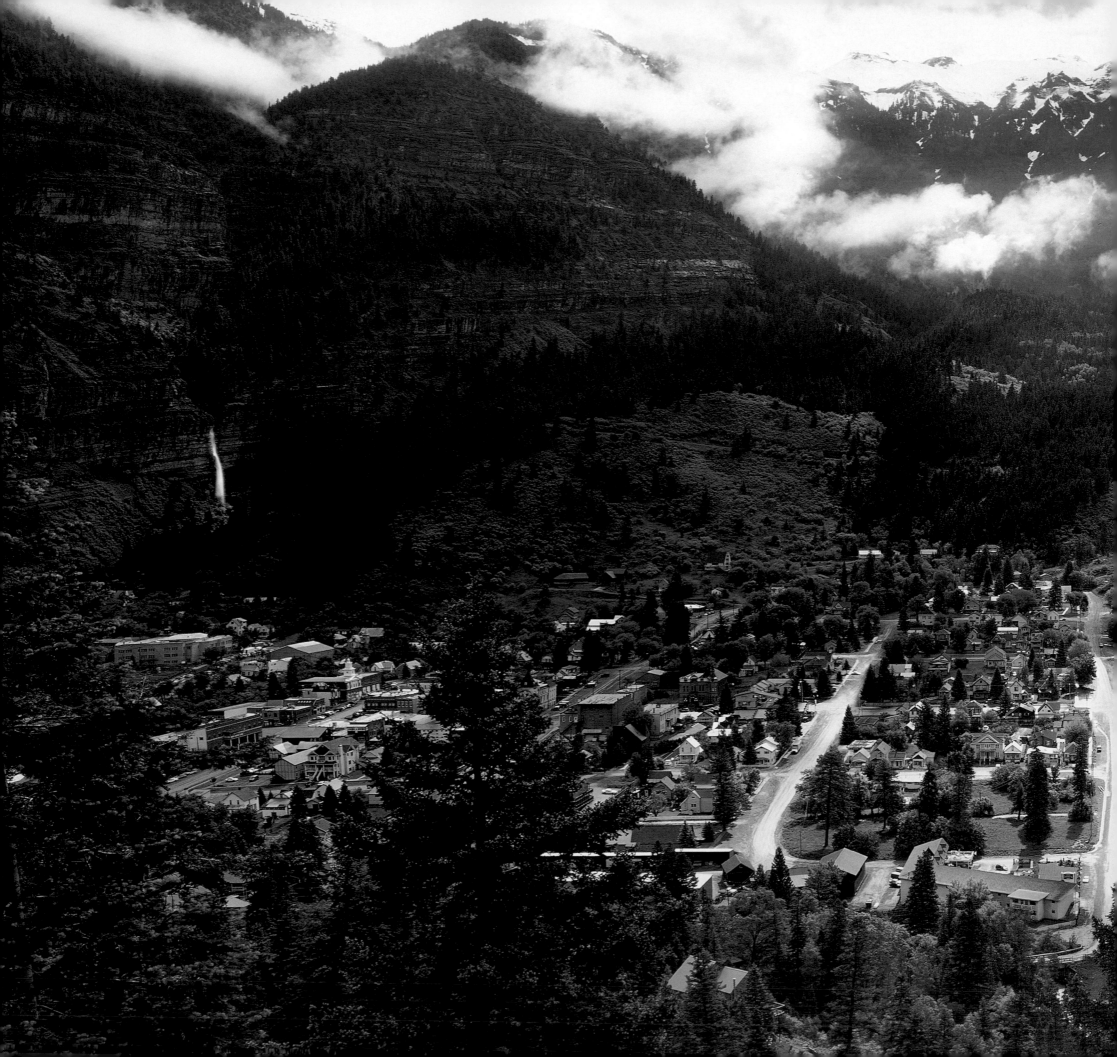

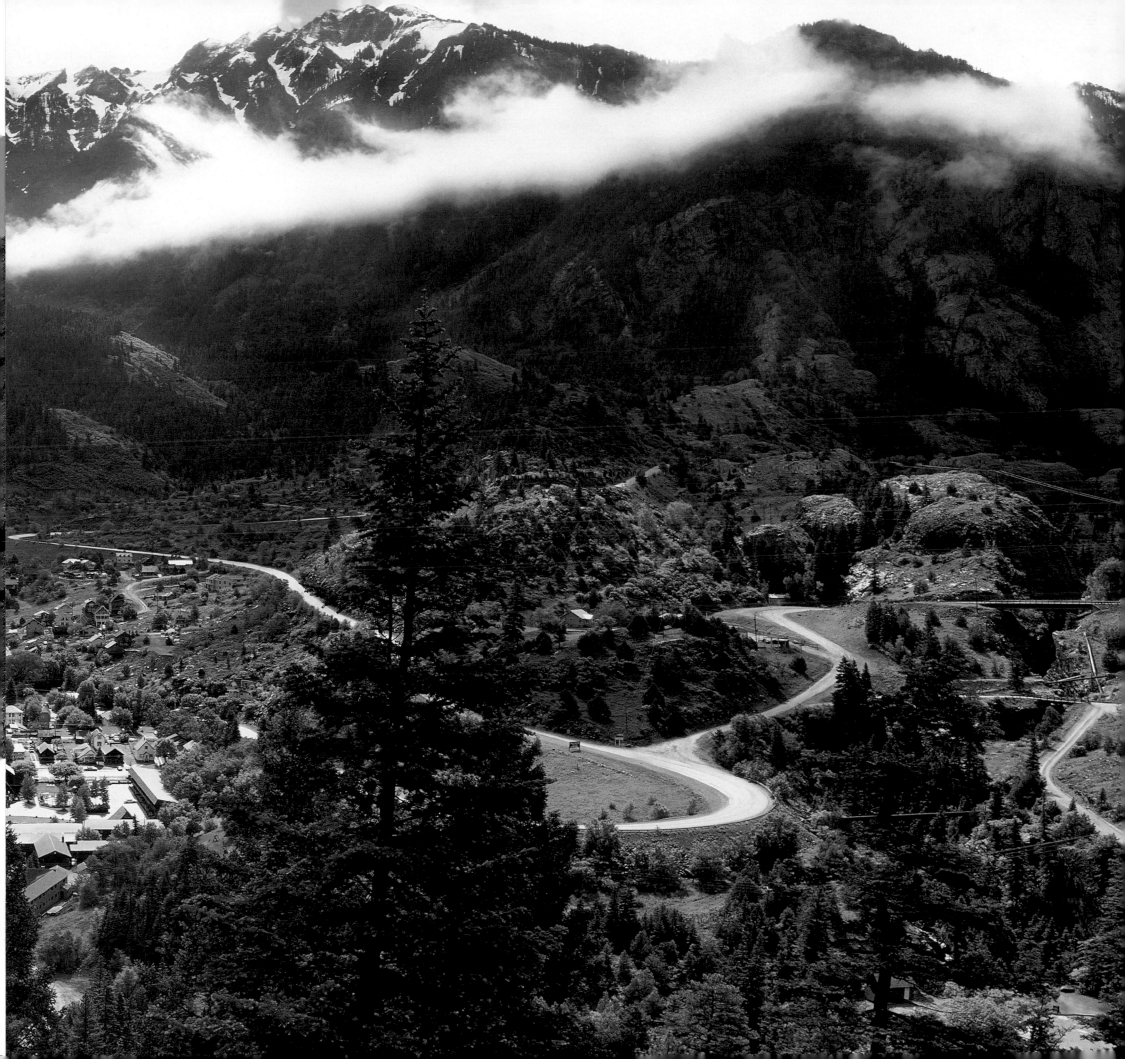

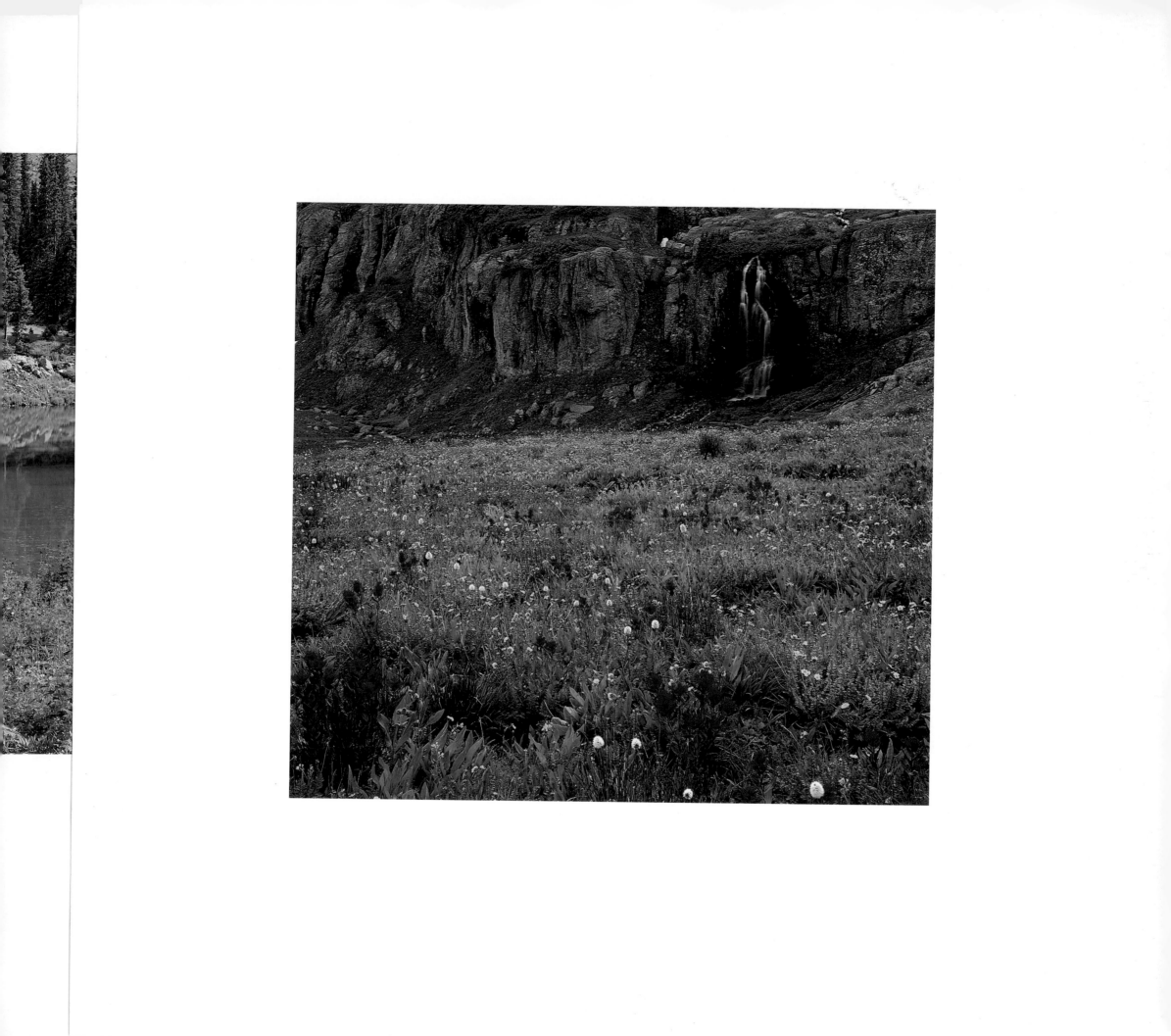

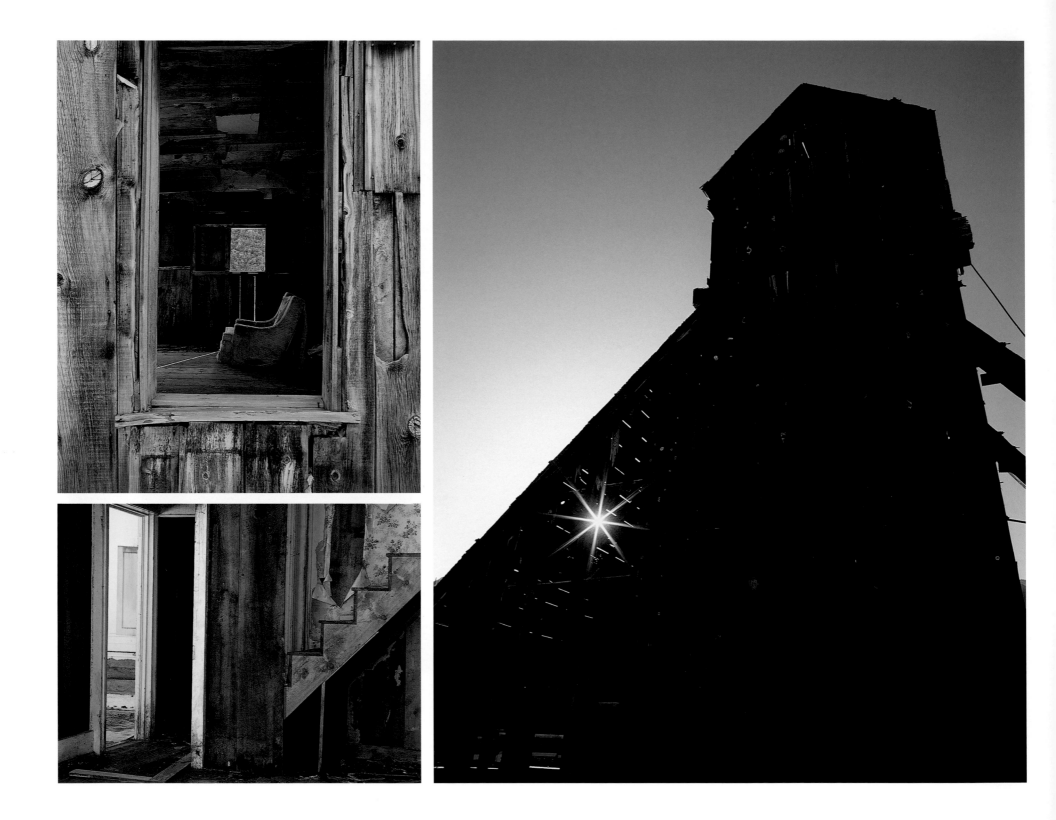

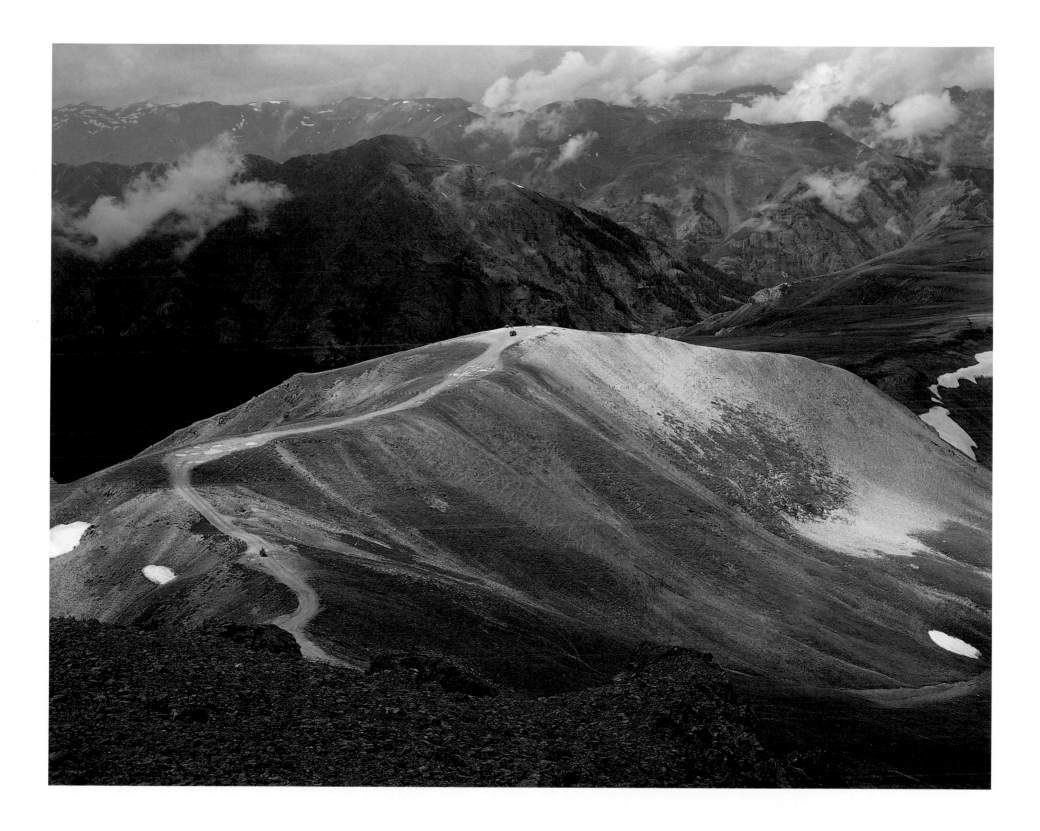

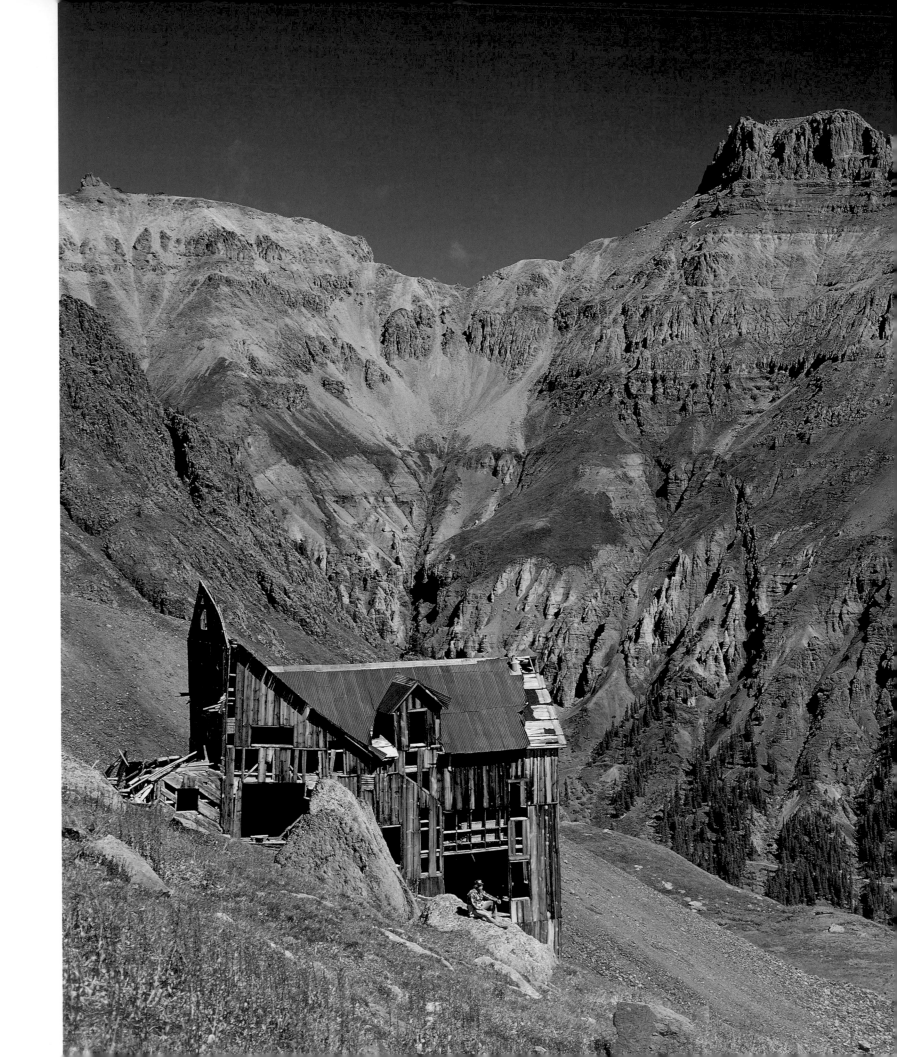

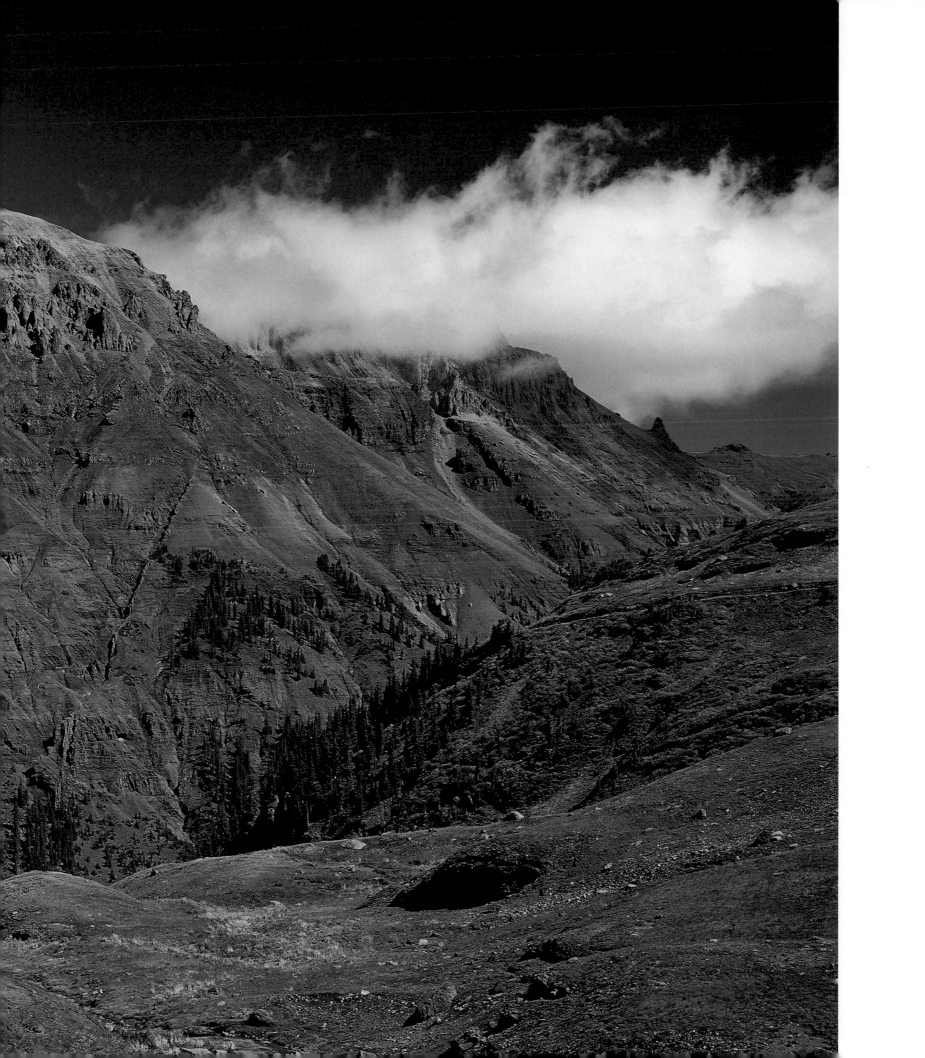

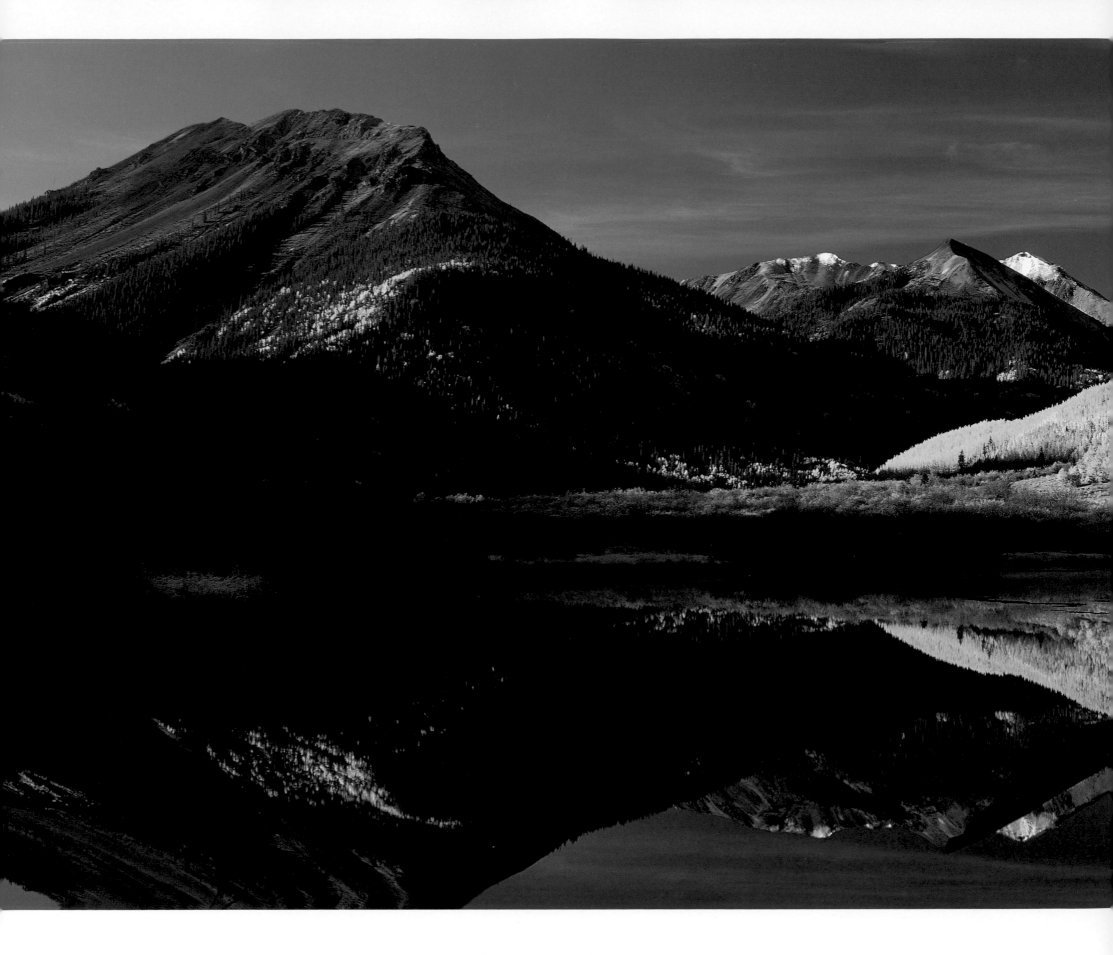

SPIRIT OF THE SAN JUANS

sixty-two

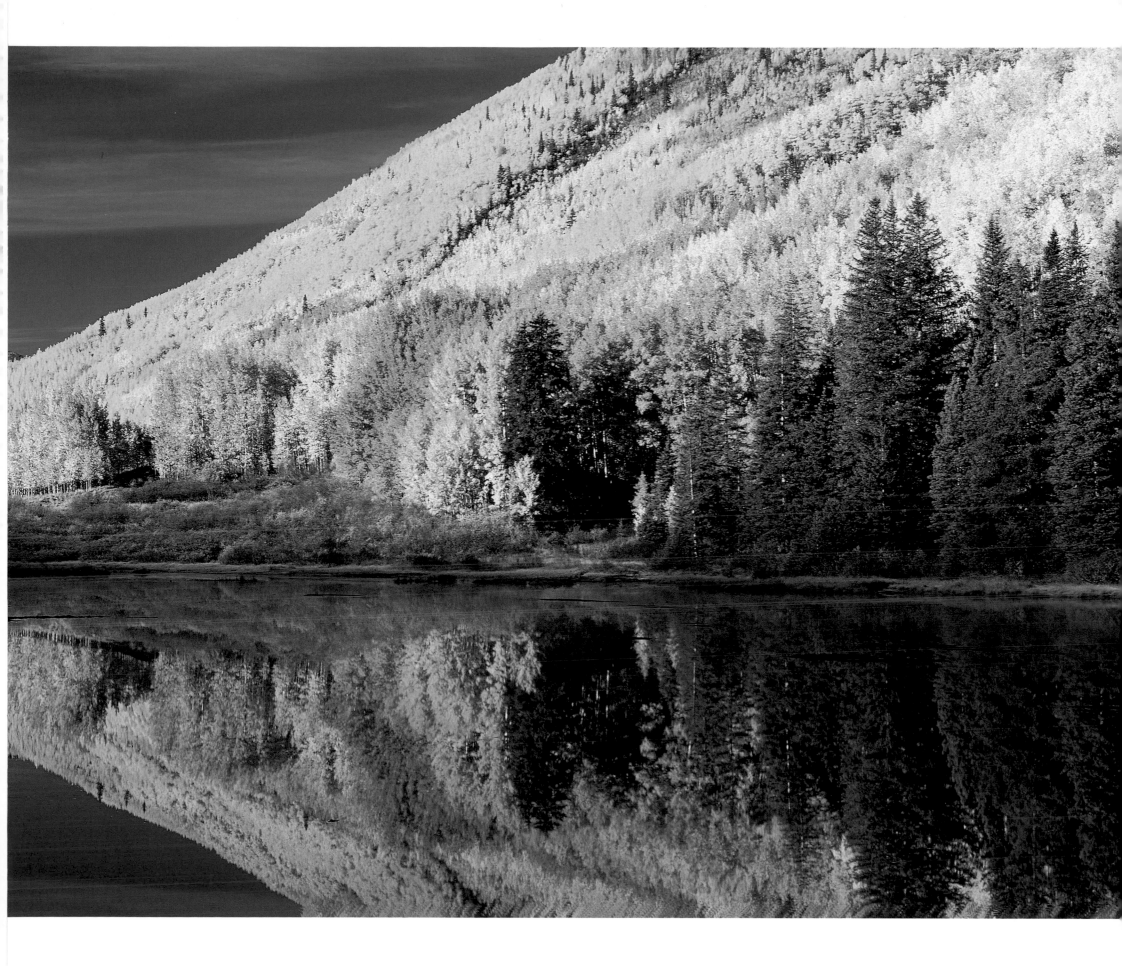

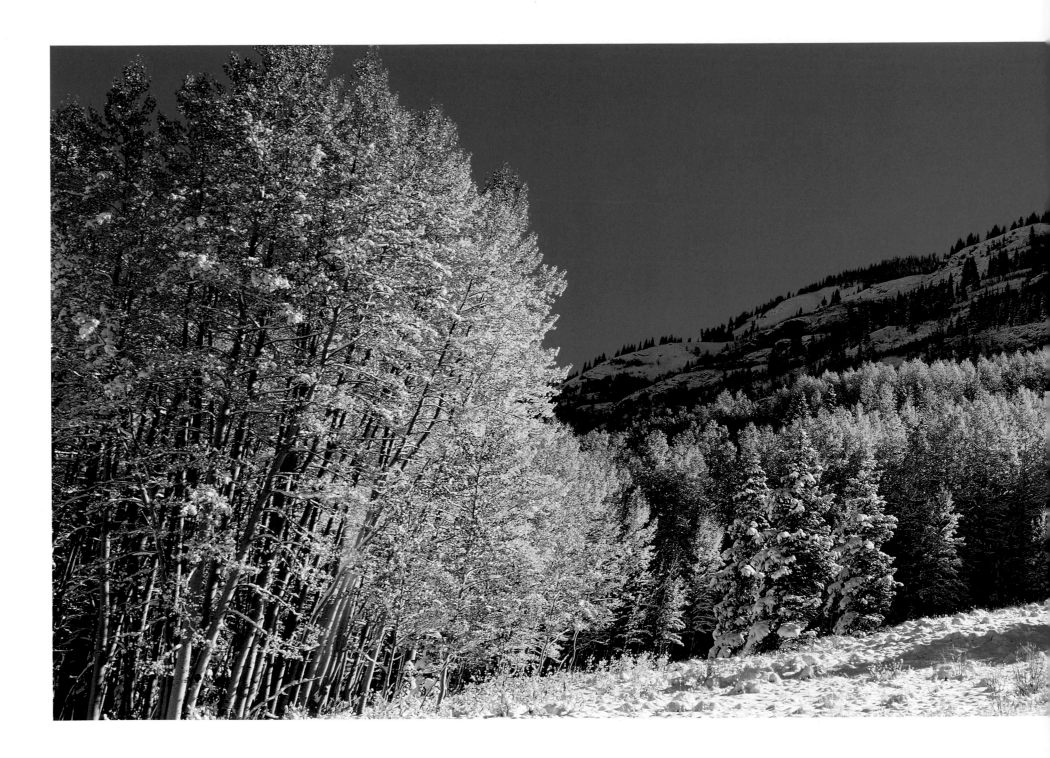

SPIRIT OF THE SAN JUANS

sixty-eight

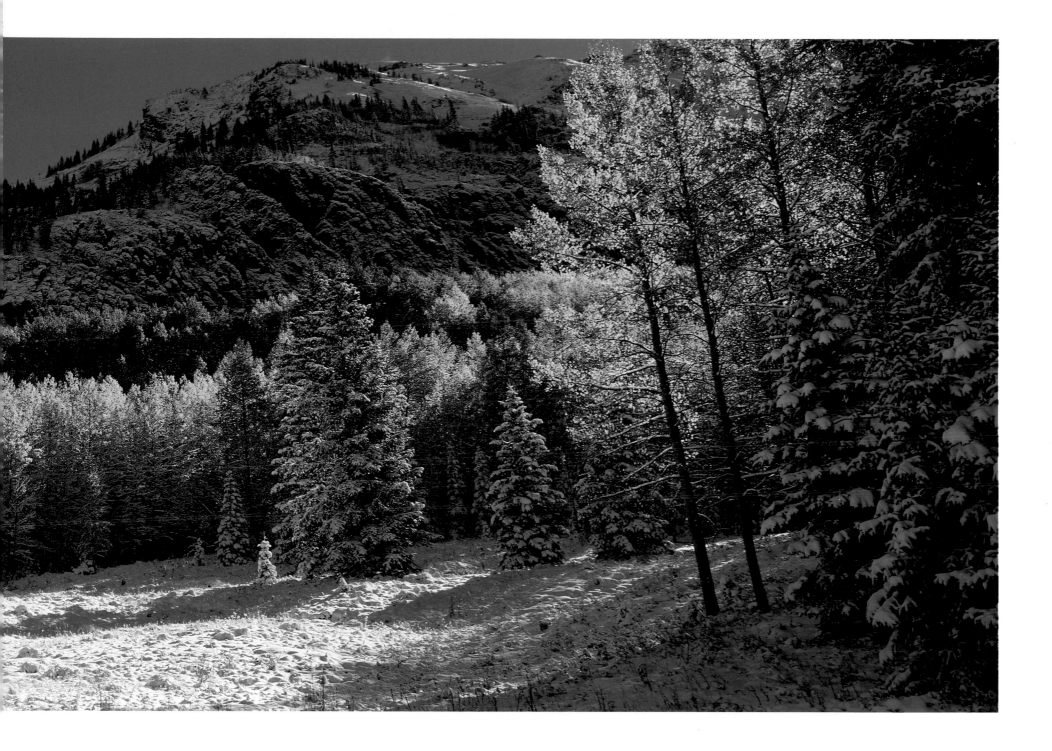

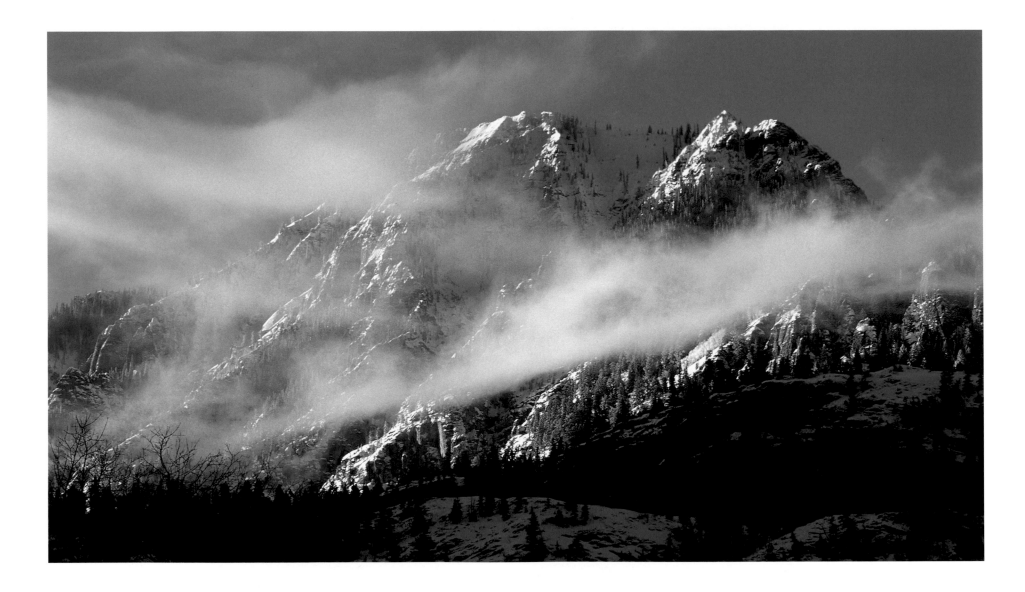

SPIRIT OF THE SAN JUANS

seventy-two

Let me

leave the plains behind,

And let me leave the vales below!

Into the highlands of the mind,

Into the mountains let me go.

—William Shakespeare

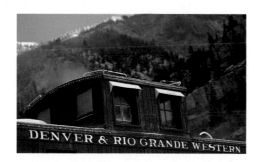

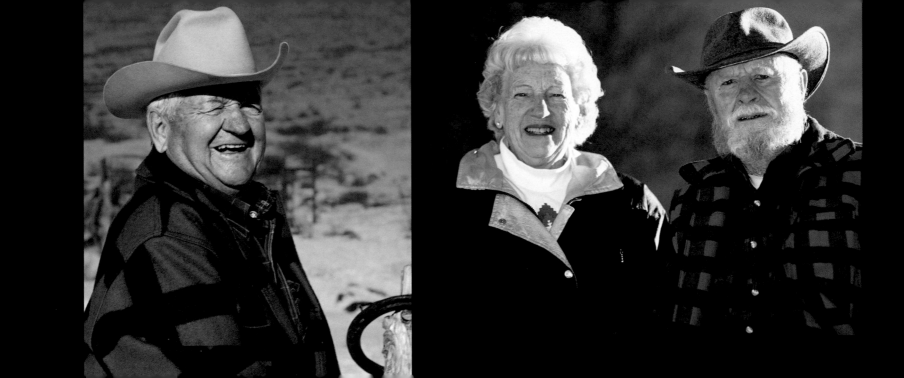

*J*oel Swank was born in 1913 in Lake City, but his family soon moved eighteen miles across the Continental Divide where Joel lived until 1930. "I used to come over on horseback to Lake City for dances. The town was full of beautiful women. My dad was a pioneer in trout-raising—the largest producer in Colorado. We would take six million brook trout eggs in the fall and about two million native eggs in the spring." Celia's grandfather sent her father and his brother to work mining property he owned near Lake City. "Unfortunately my father died just shortly after my birth during the great flu epidemic of 1919. After returning from World War II, Joel was hired as superintendent of county roads. "They gave me $600 to complete the road from the top of Cinnamon Pass down to Animas Forks. Jeeps were coming to our area after they were such a huge success in the war. We had the second jeep that came to Hinsdale County. We filed for a permit and got to haul passengers over the road I built." Celia laughs as she mentions that "he took a couple of trips and said he had so much to do that I needed to take those trips. I told him I had a motel to take care of, but he said, 'Somebody's got to drive them.' I drove for fourteen years." During Joel's diverse life, he ran a sawmill, owned a liquor store, was mayor of Lake City (five times), county commissioner, rancher, professional guide, president of a major electrical utility, school board president, marshal, and judge. "I wake up daily and look around and thank the good Lord that I live here. These mountains really got it over the plains even though your eyes butt up real short," smiles Joel. Celia simply says, "The mountains are home—I'd be lost without them."

*P*erk Vickers' family has lived in Lake City since the 1870s. His father ran a saloon. "My dad lived to be 94. At the time I was born, Lake City was a thriving community. When I was a boy we'd see one or two trains come up this canyon every day. When the mines shut down everything stopped. It looked like the end of Lake City. We had eight kids. In order to support the family, my dad put the upper ranch together. I've always been partial to miners, and I've always been supportive of the tourist business. You can go down any of these canyons and see that the tourists love these mines. They spend half their time looking at them. We can have a compatible community of mining and tourism, but it has to be done in an orderly way. You've got to have environmental concerns, but sometimes they get out of line. This is our sixty-seventh year with cabins in the dude ranching business. We are the oldest licensing outfit in the state of Colorado." "I found out early in life that if you are close to God, it's got to be in these mountains. We have a cookout every Wednesday of the summer at the top of the mountain—we call it Vickers' Mountain. Everyone brings their own steak and a covered dish. They always agree—it's as close to heaven as you'll ever get. The federal government owns ninety-five percent of the land around here so we are not going to get overcrowded. One of the best things I like about the mountains is the solitude, even though I've been involved with the public all my life. I love these mountains. We're blessed by the hand of God."

Above us,

infinity and space

Around us, tapering shadows

Within us, quiet and

Secrets of a million decades.

—Dan Roberts

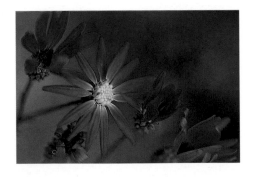

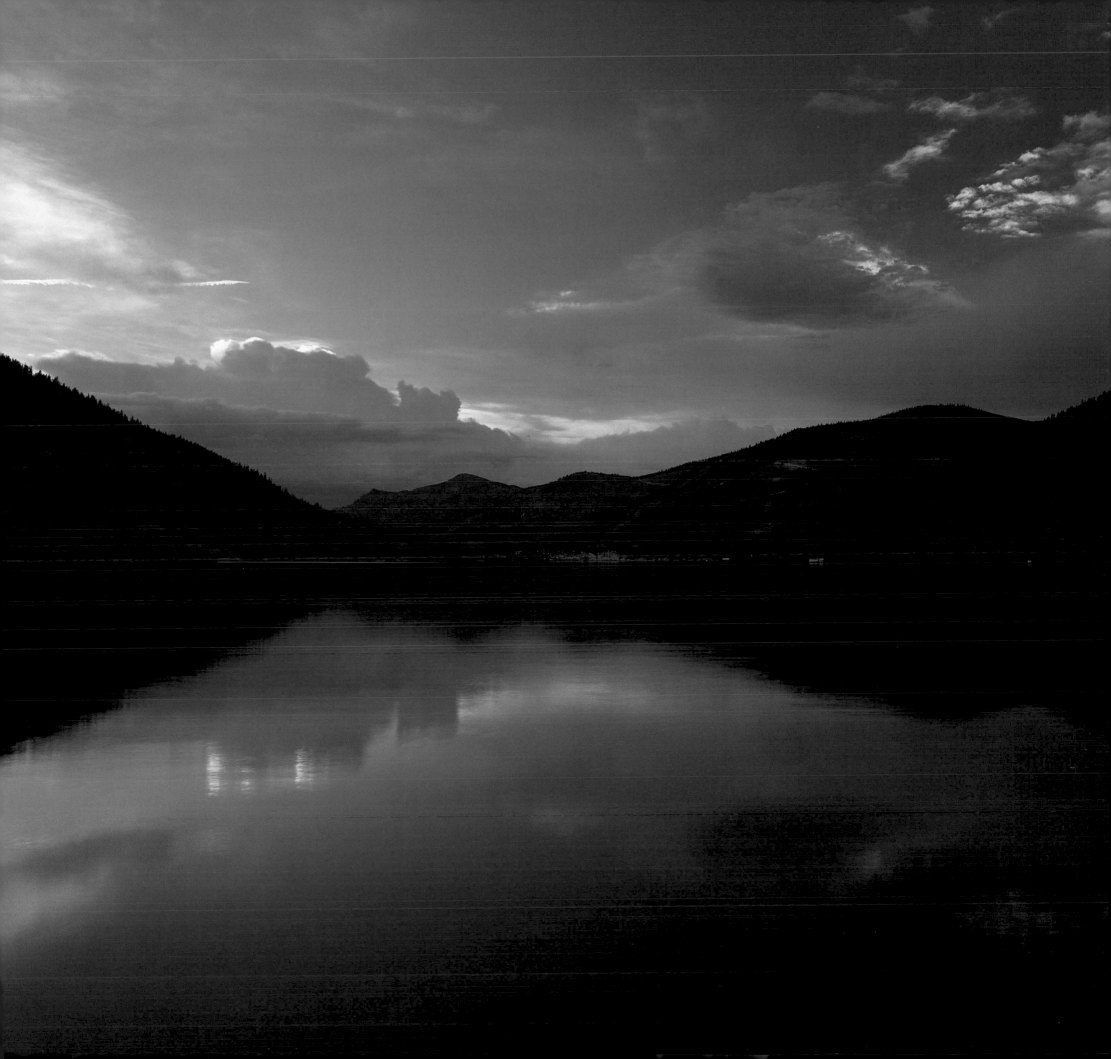

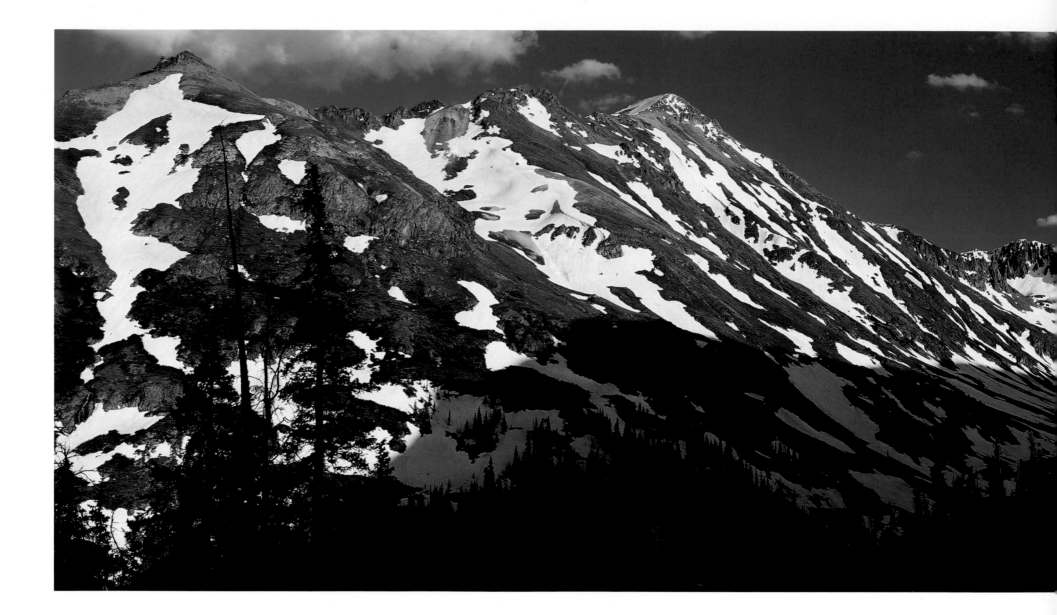

SPIRIT OF THE SAN JUANS

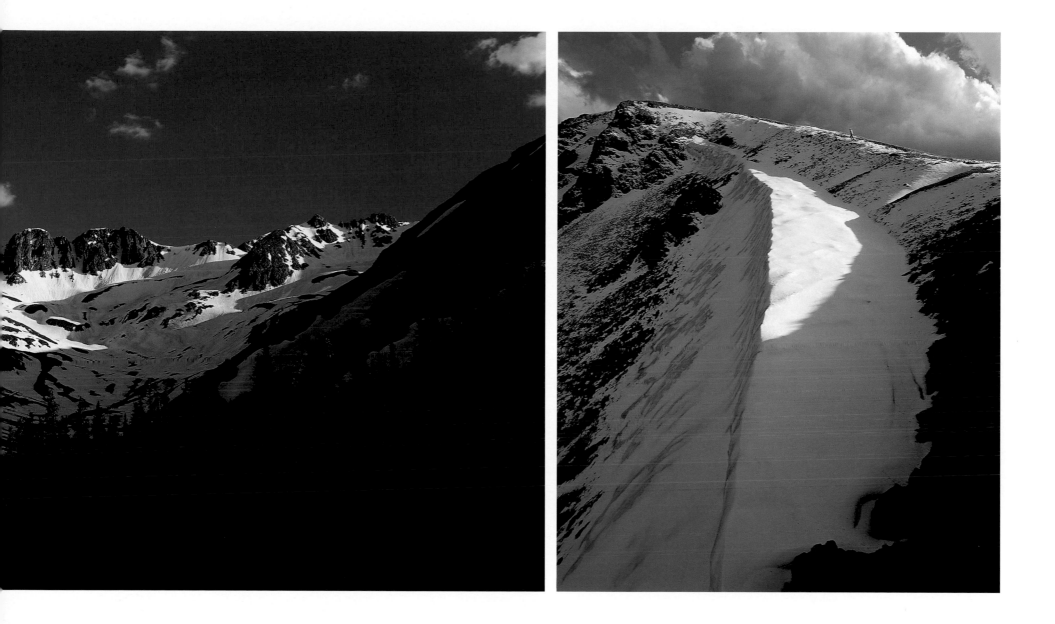

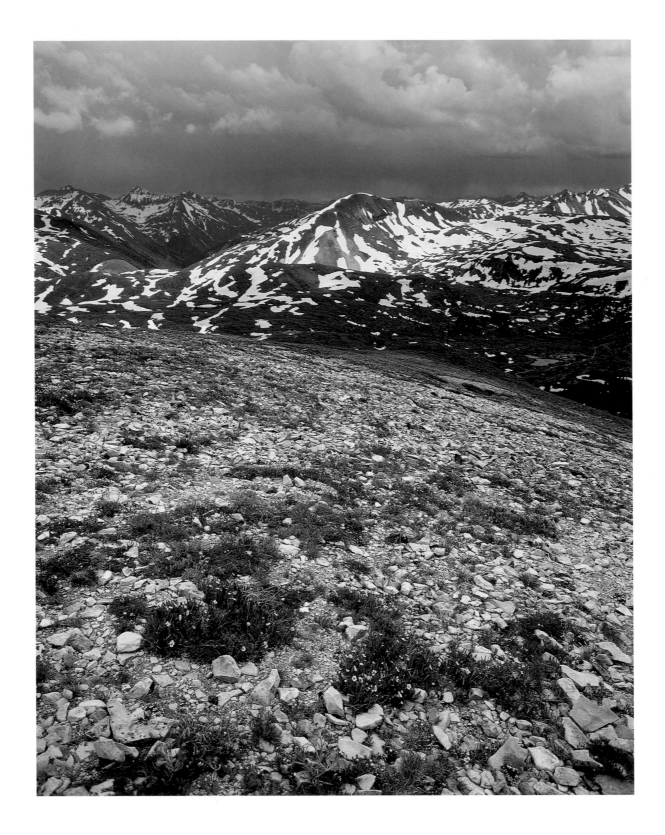

SPIRIT OF THE SAN JUANS

eighty-four

*S*tanding alone,

on the mountaintop it is easy to realize

that whatever special nests we make—

leaves and moss like the marmots and birds,

or tents or piled stone—

we all dwell in a house of one room,

the world with the firmament for its roof—

and are sailing the celestial spaces

without leaving any track.

—JOHN MUIR

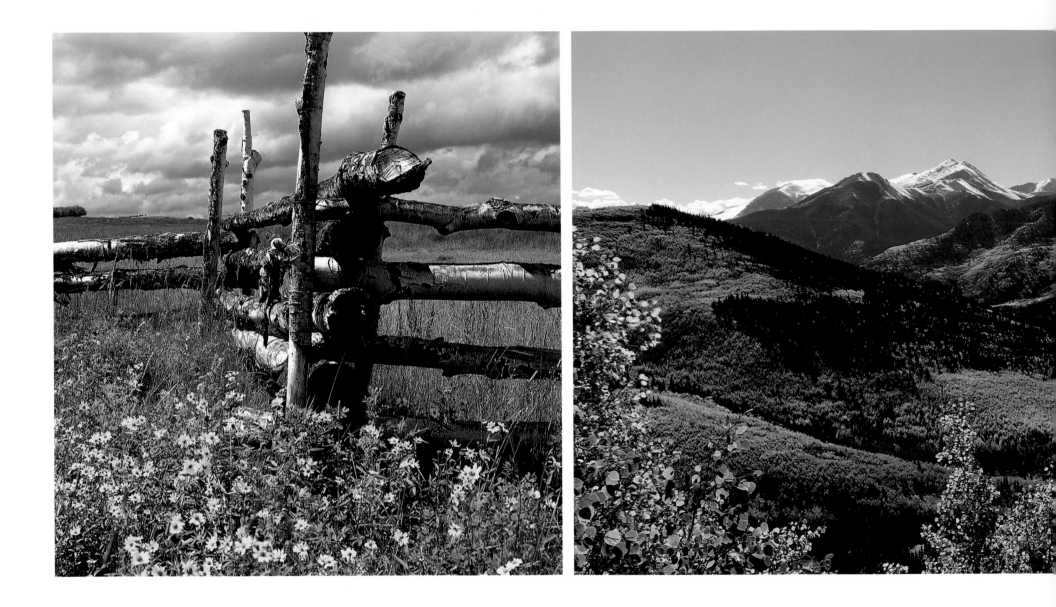

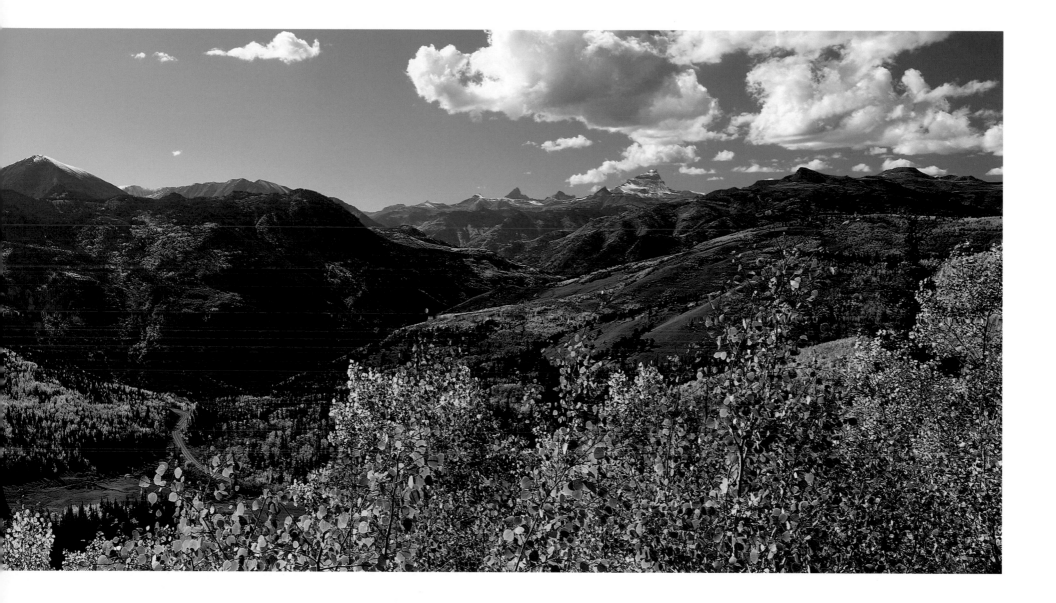

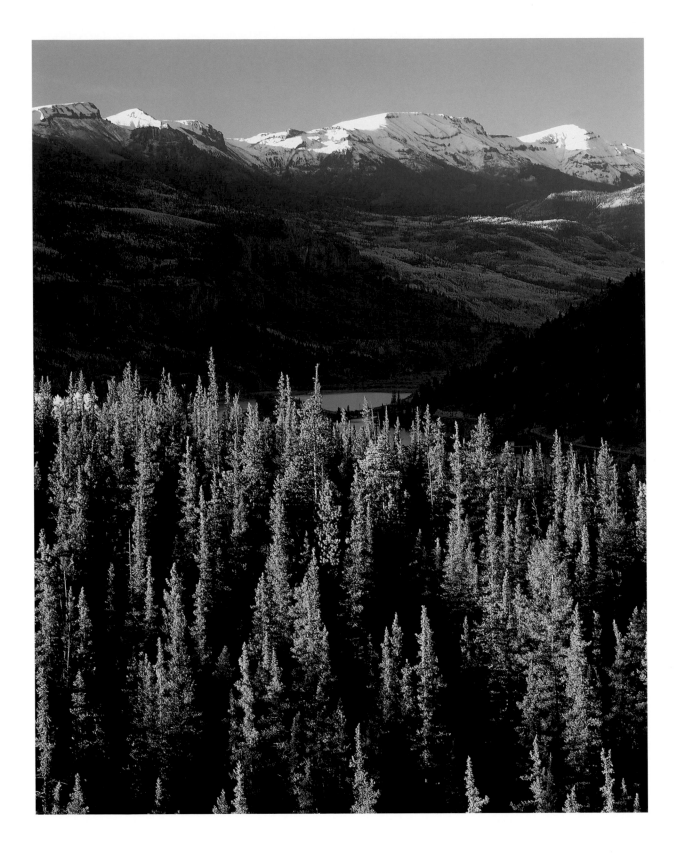

SPIRIT OF THE SAN JUANS

eighty-eight

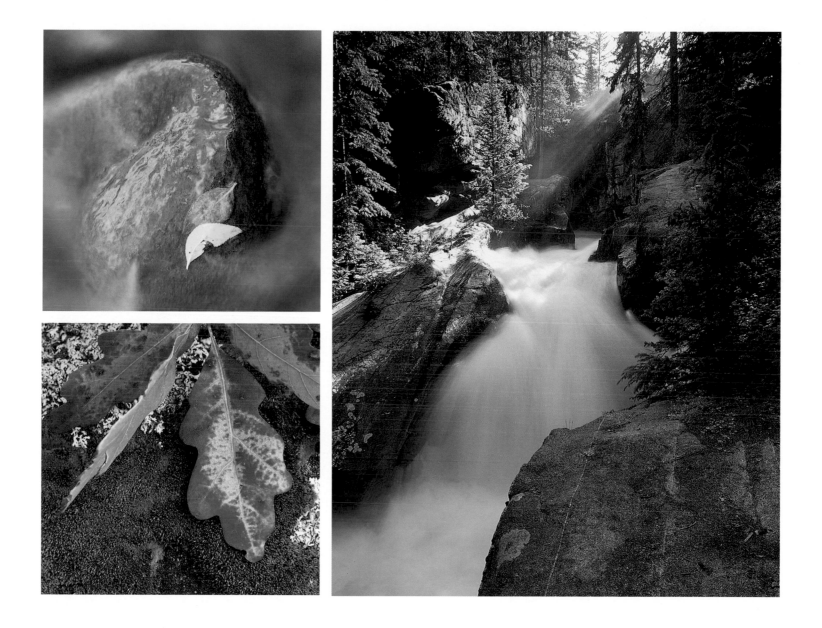

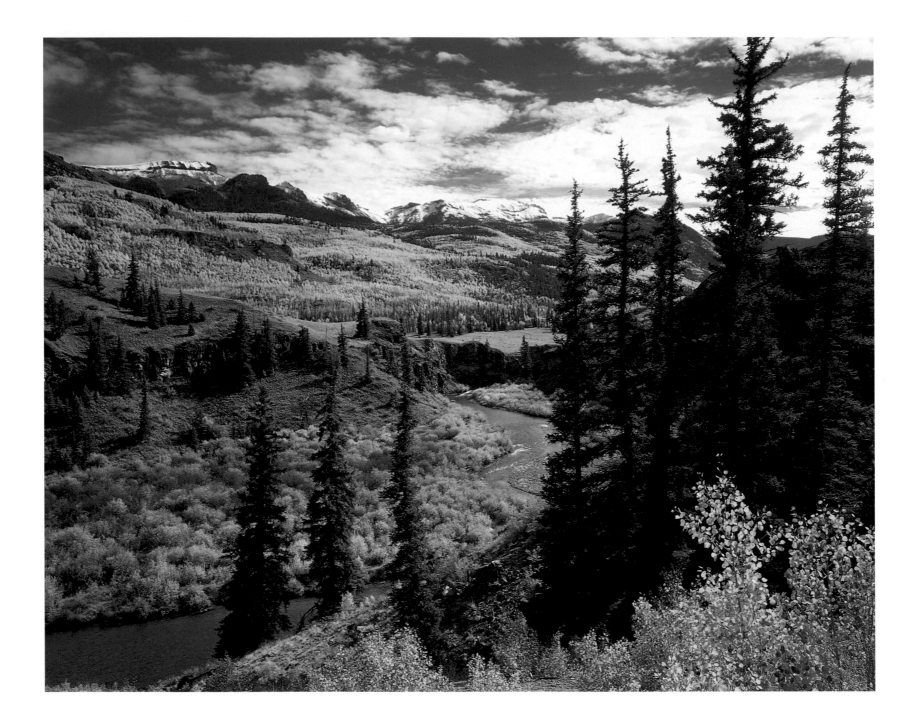

SPIRIT OF THE SAN JUANS

ninety

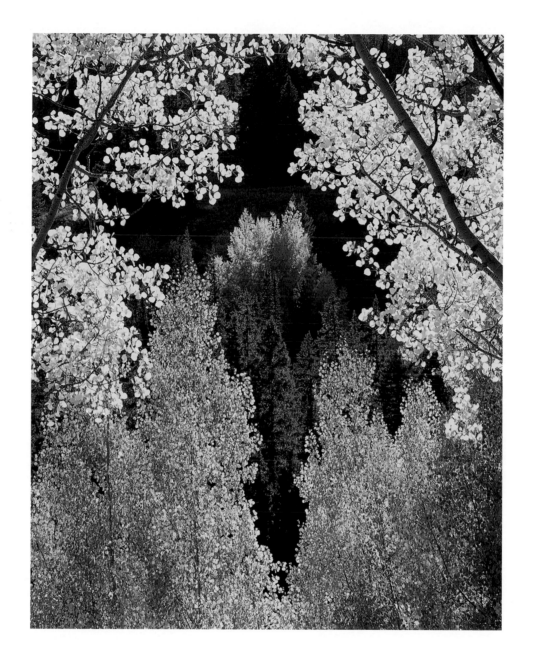

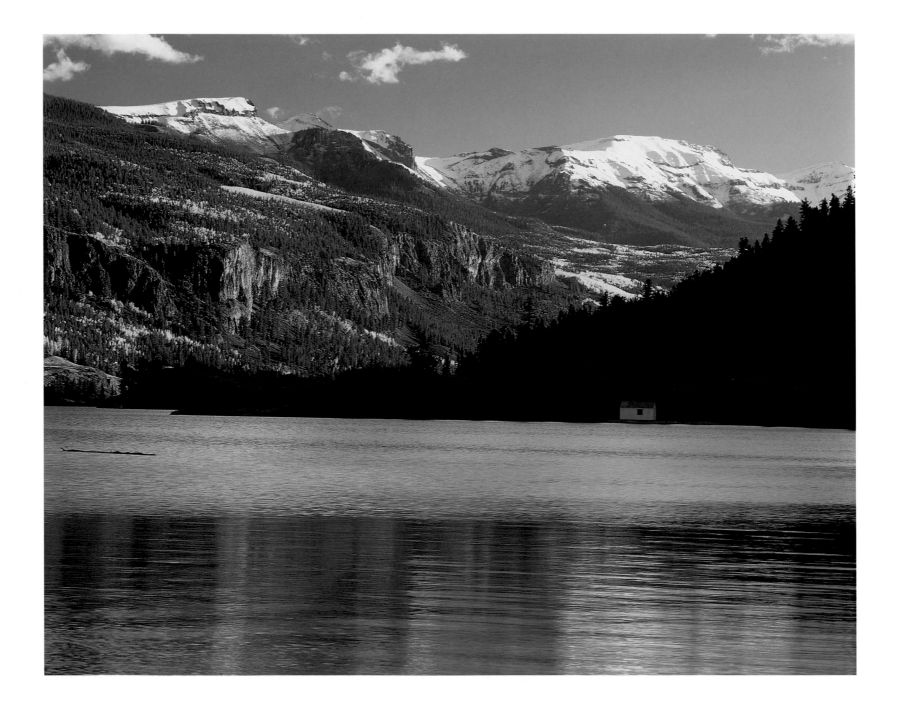

SPIRIT OF THE SAN JUANS

ninety-two

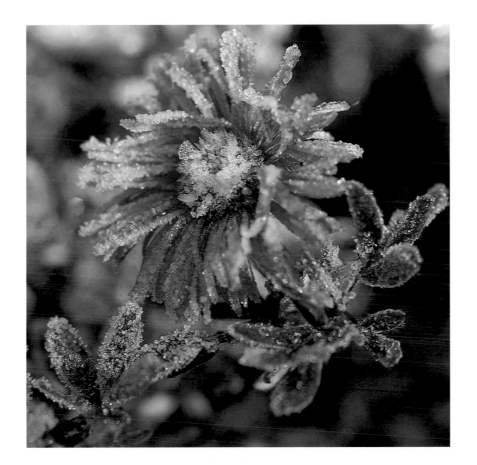

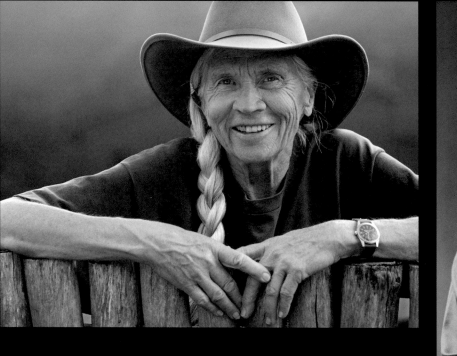
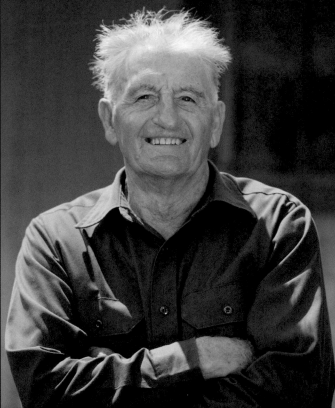

*D*olores LaChapelle is an author, teacher, explorer, extreme skier and pioneer in "earth wisdom" who came to Silverton in 1973 with her husband who, at the time, was under contract to study avalanches in the San Juans. ◦∽"I grew up in north Denver. I was a tree climber. My sister and I joined the Colorado Mountain Club as teenagers. I've been climbing ever since. I've climbed all the fourteeners in Colorado but, more importantly, I've climbed all the 13,000 ft. peaks which ring Silverton. I love the aspen around Silverton. I do most of my workshops outside and I walk daily around Silverton. The fall colors are here by the end of August. Then I go to Lime Creek and below and they last until mid-October. The San Juan country is still wild. It's not like the central Colorado mountains and not easy to get up into because of the glaciers. The lower slopes of the San Juan Mountains are very steep. The glaciers carved the rock away. Up higher, the mountains level out and are connected by ridges which were not cut by glaciers. Up high you can wander anywhere." ∽Dolores writes and speaks frequently on ecology. "We are a part of nature, and therefore we are a part of the ecology. 'Deep ecology' refers to our innermost thinking and being. We need to be aware that we are a part of nature, not separate from it."

*J*oe Todeschi was born in Silverton in 1915. His father died soon after he graduated from high school. "When we got his last check from the Shenandoah-Dives Mining Company, it only amounted to $3.25. He had owed the company for watch repair and room and board. He also had been ill. In the spring after my dad died, I went to work at the railroad yard. In those days they called people who worked on the railroad 'gandy-dancers.' Pete Huron, the section boss, said 'Kid, I'd like to give you a job but you're too light. A day's work is to remove fifteen ties and replace them.' I said, 'Give me a chance. You know, we've got to eat.' It about killed me the first couple of days. I got $2.42 a day. I was interested in what I could bring home and give to my mom. I always sent my checks to my mother." Joe worked as a mechanic, an electrician, a bartender, a welder and eventually became foreman of the San Juan County road crew. He retired at age seventy. ∽Joe remembers skiing and skating parties as a child. "We had homemade skis with barrel staves. We'd get an old pair of shoes, cut them apart and nail them onto skis. To go uphill we'd put gunnysacks on the skis so they wouldn't slide. There were no rope tows. We'd also go into the mountains in summer to look for pine mushrooms and dandelions to eat. My mother would cook the dandelions in water like spinach and serve them with vinegar and oil and maybe a hard-boiled egg. These mountains look the same to me now as they have for as long as I can remember. That's my idea of what life is all about. You're here for a short time, do the best you can with what you got and then it's 'Goodbye, Charlie!'"

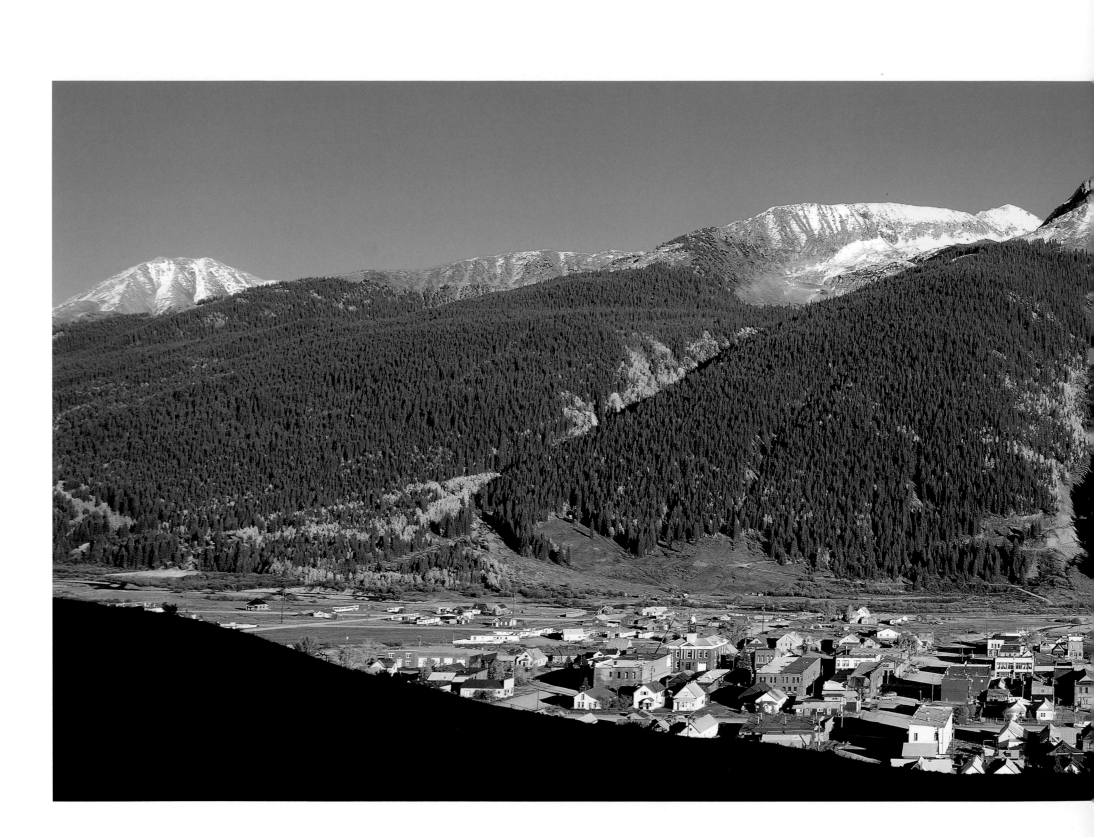

SPIRIT OF THE SAN JUANS

ninety-six

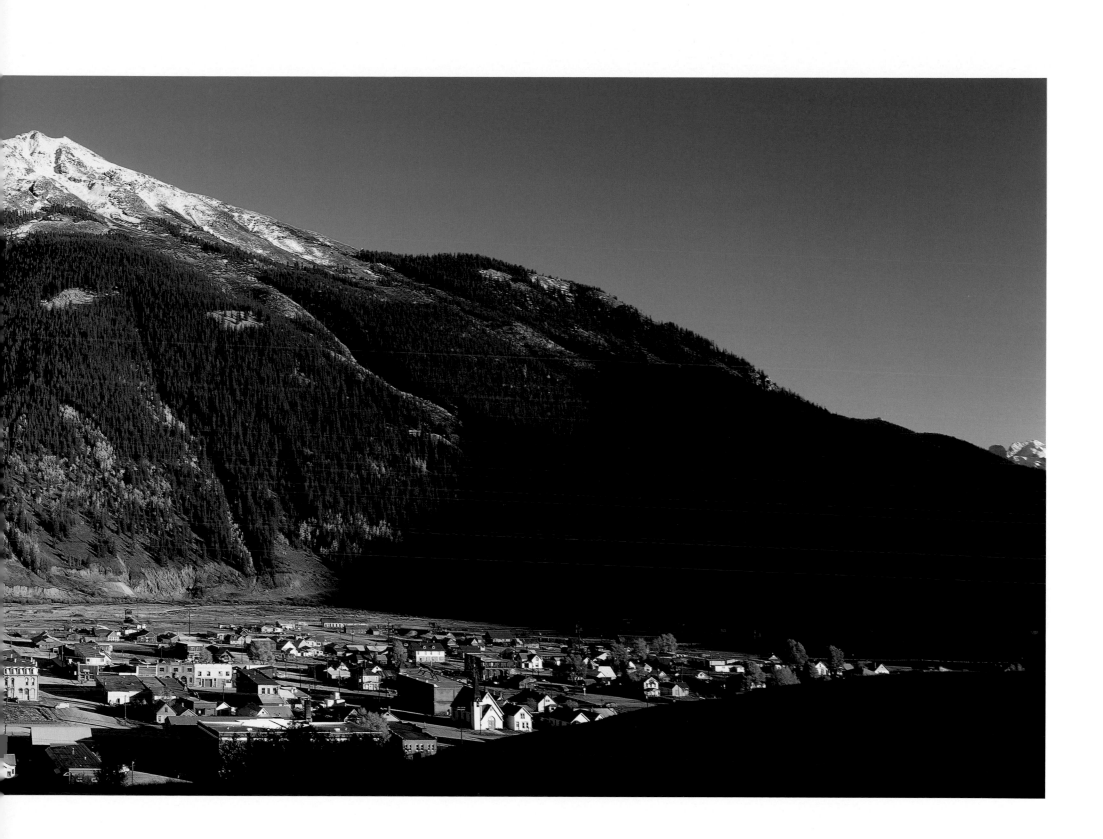

o see

a world in a grain of sand

And a heaven in a wildflower,

Hold infinity in the palm of your hand

And eternity in an hour.

—WILLIAM BLAKE

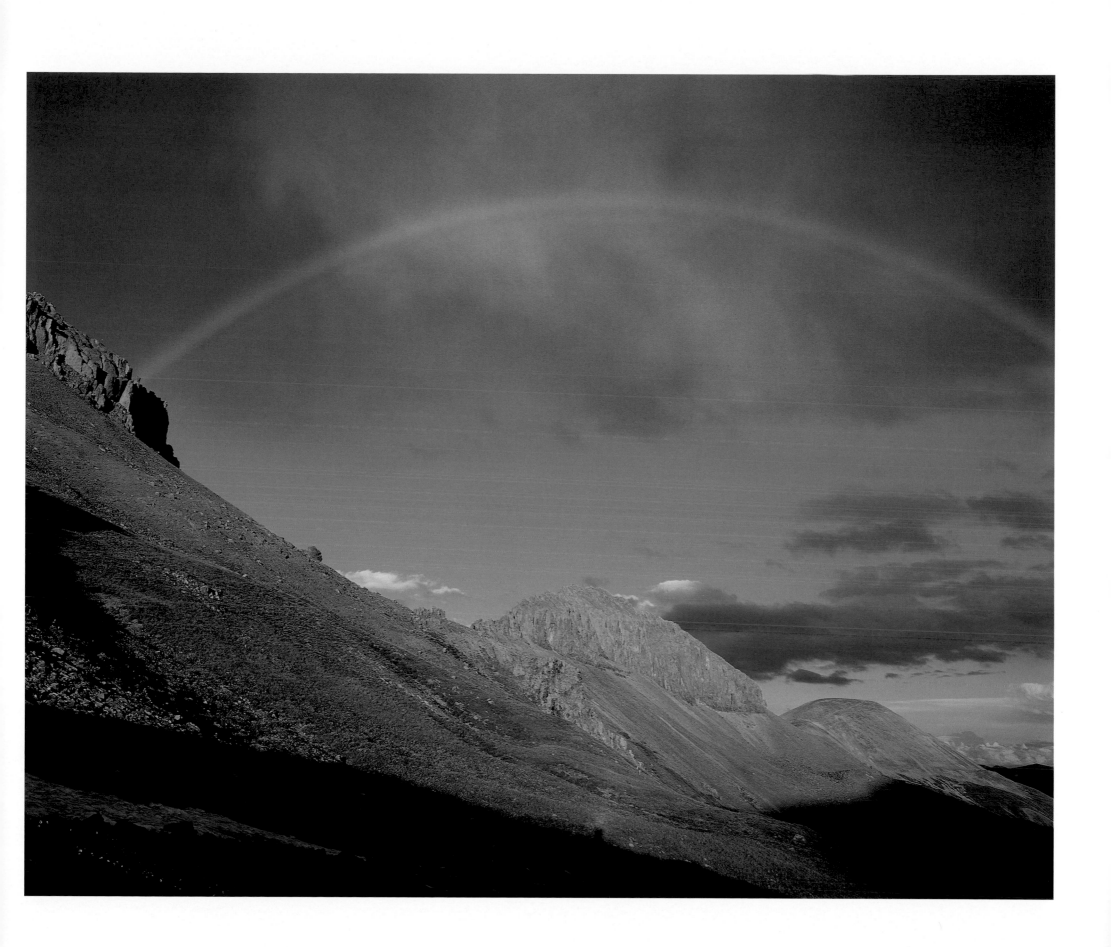

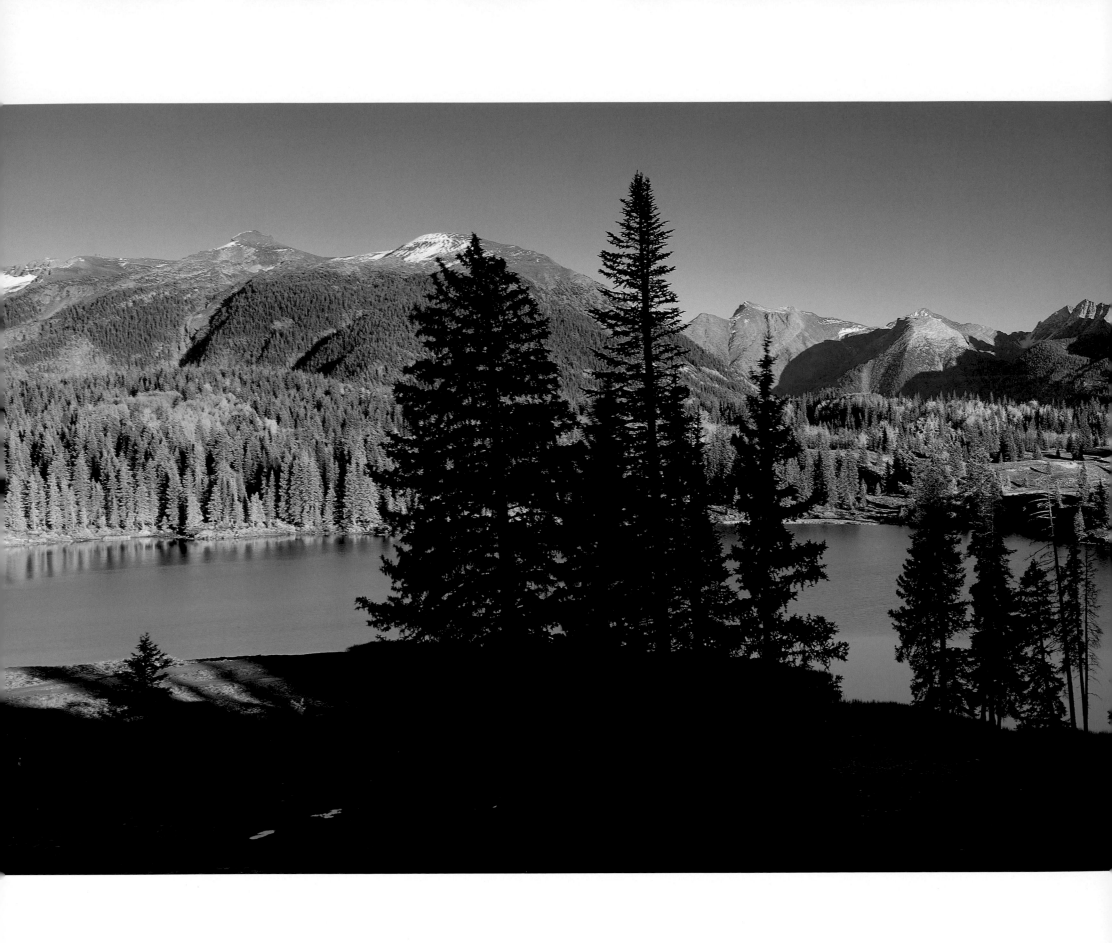

SPIRIT OF THE SAN JUANS

one hundred

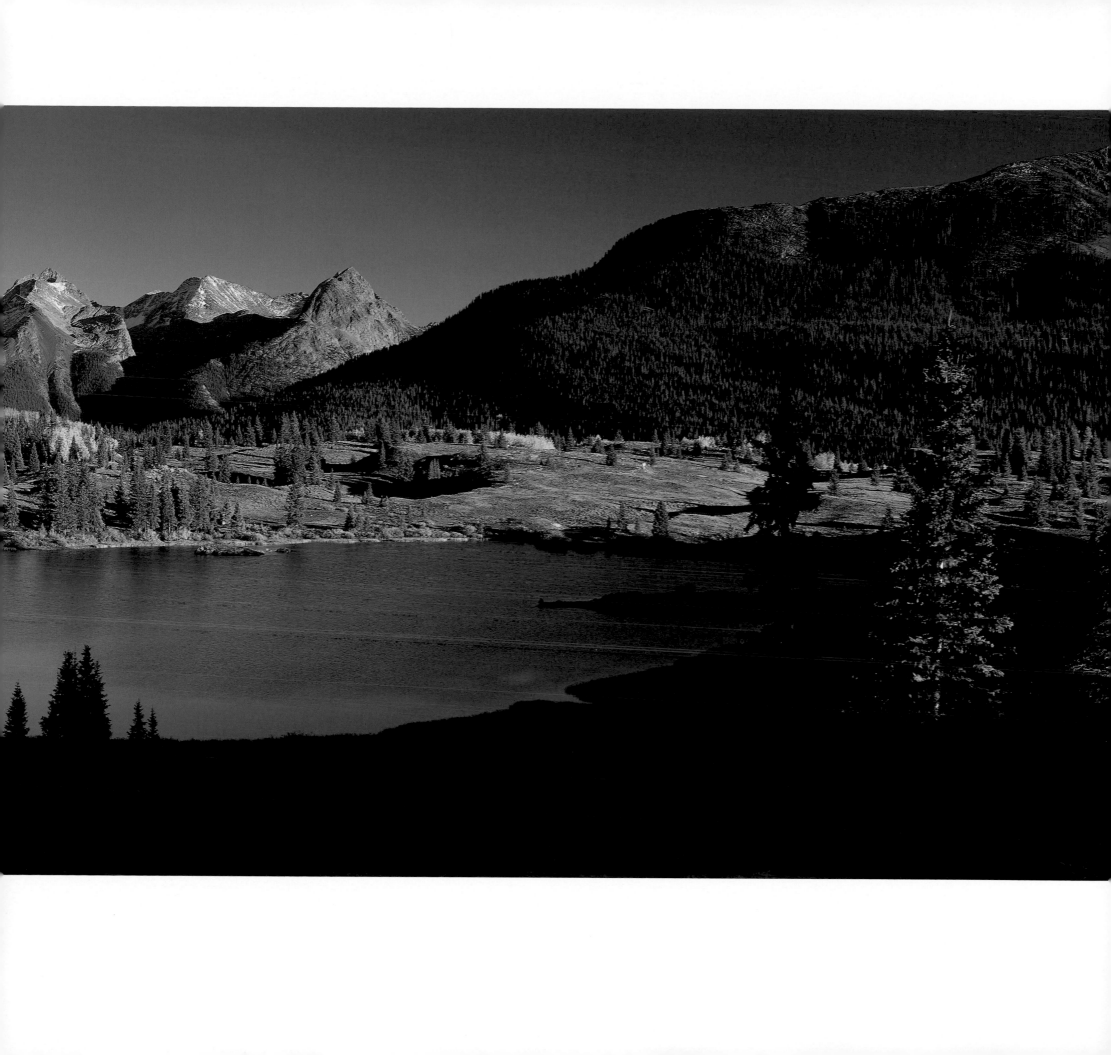

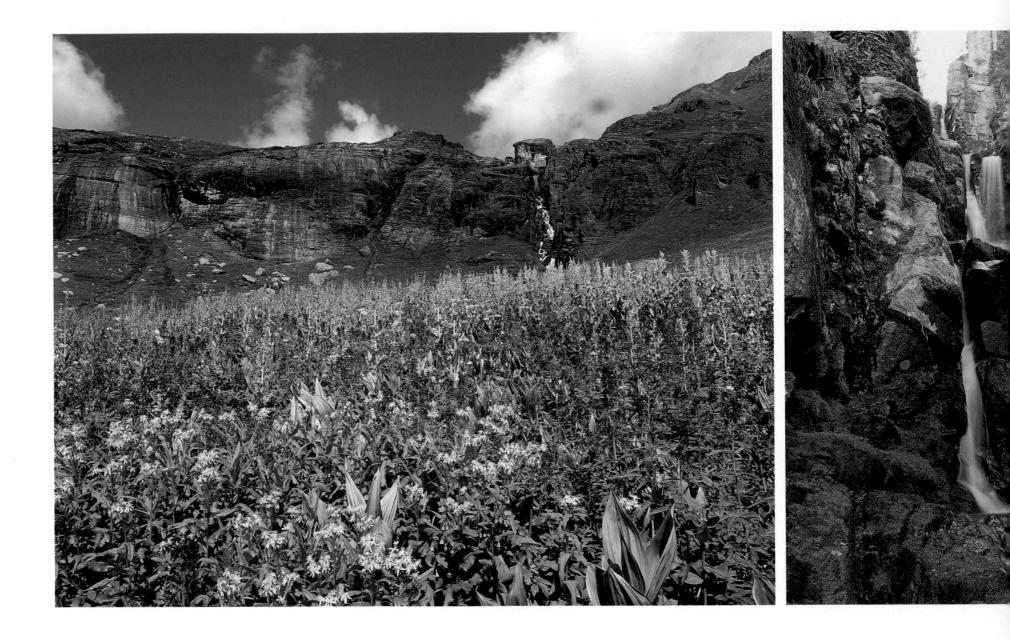

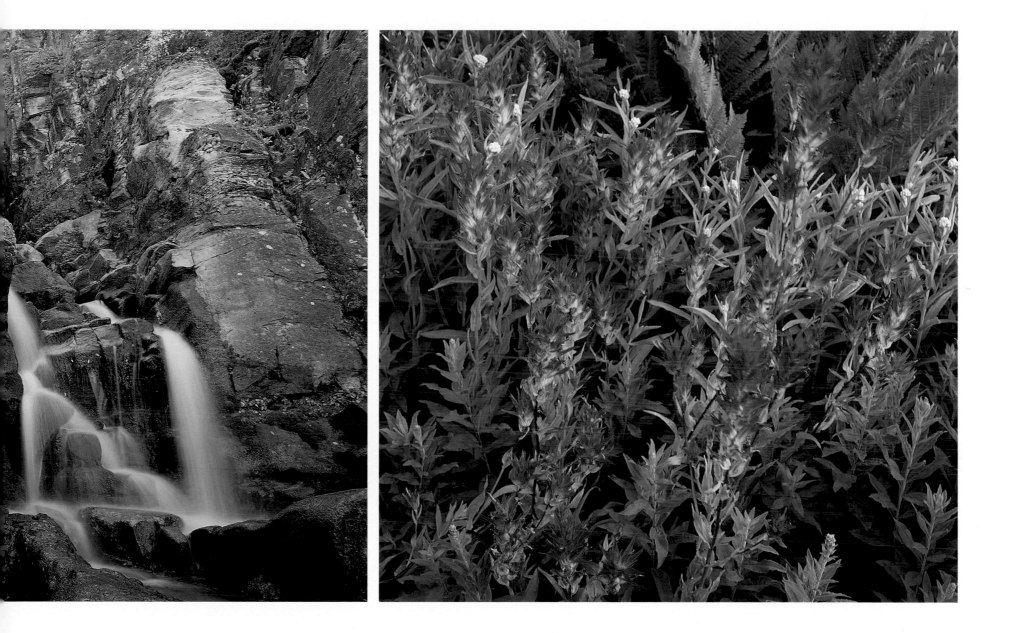

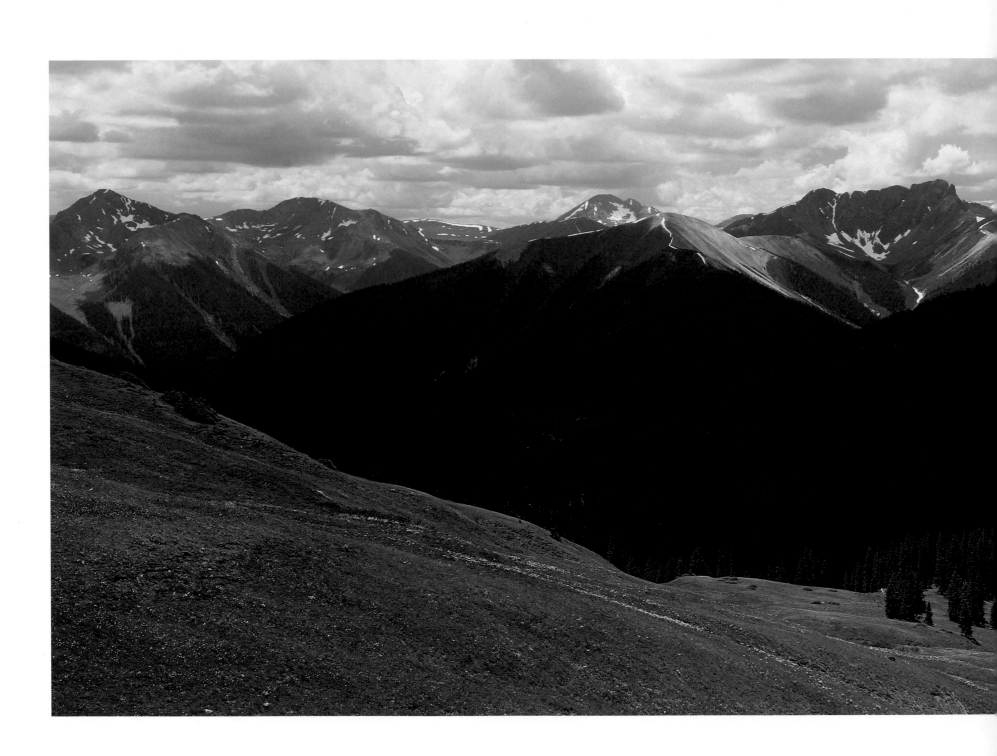

SPIRIT OF THE SAN JUANS

one hundred four

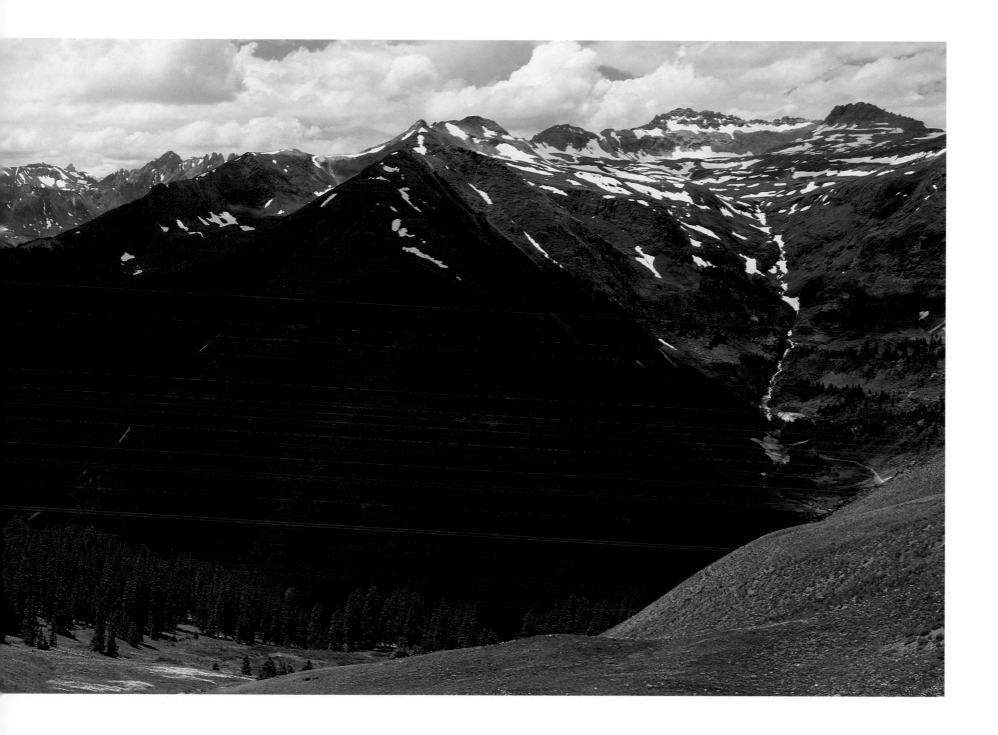

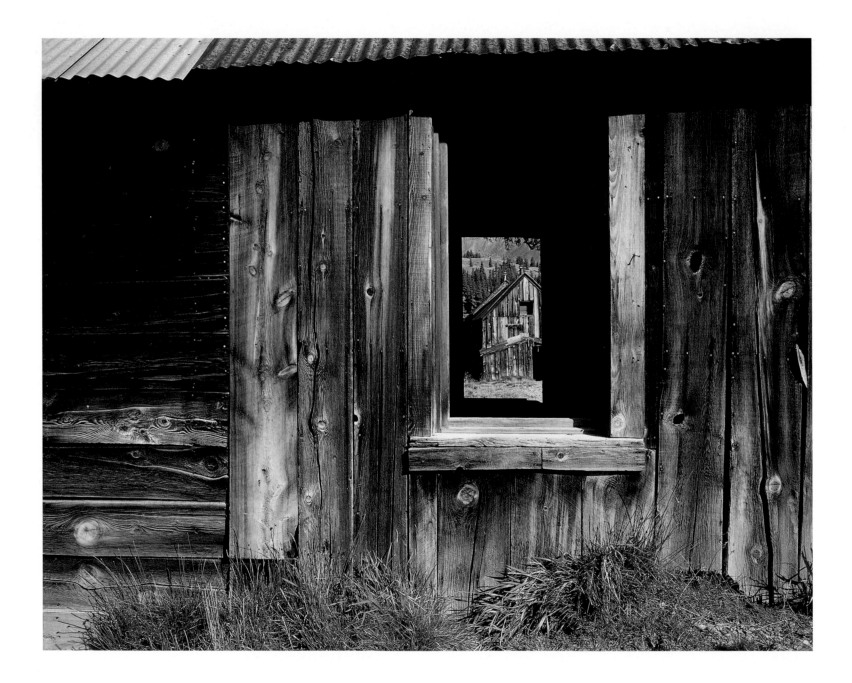

SPIRIT OF THE SAN JUANS

one hundred six

And reaches for the

Morning glow that wakens

The silence, covering

Lonely cabins

Of a hundred years.

It is I, the mountain, that

Can tell a longer story—listen.

—Dan Roberts

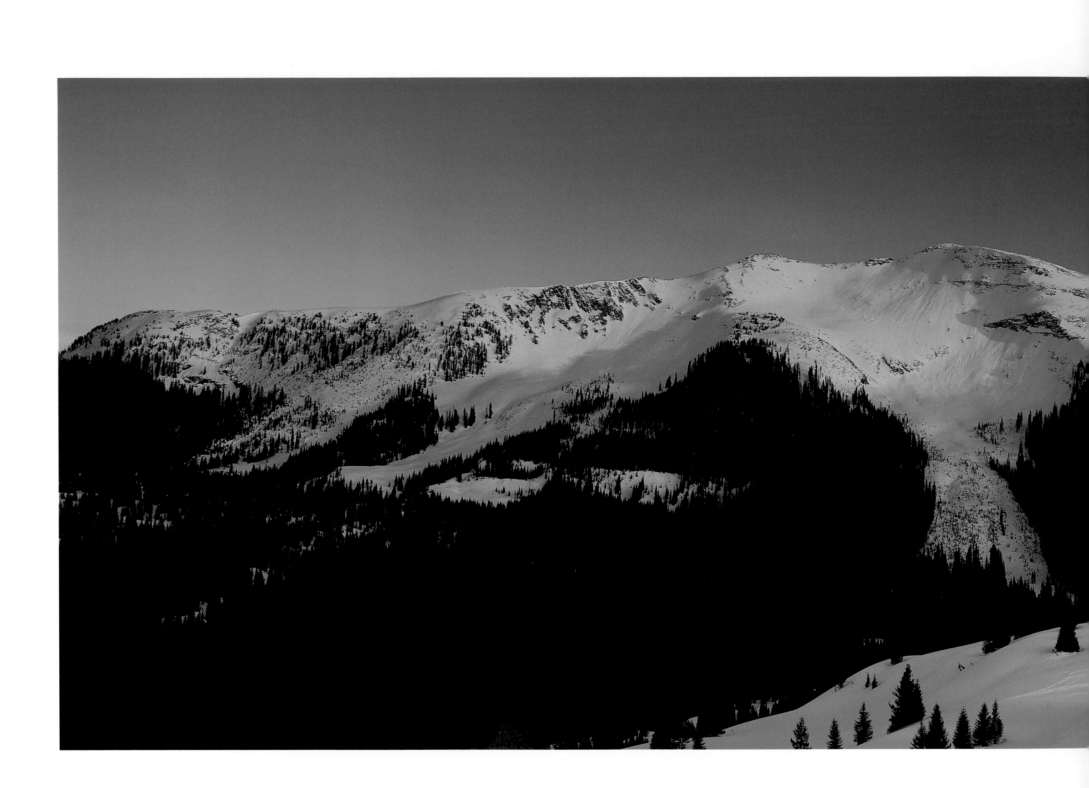

SPIRIT OF THE SAN JUANS

one hundred ten

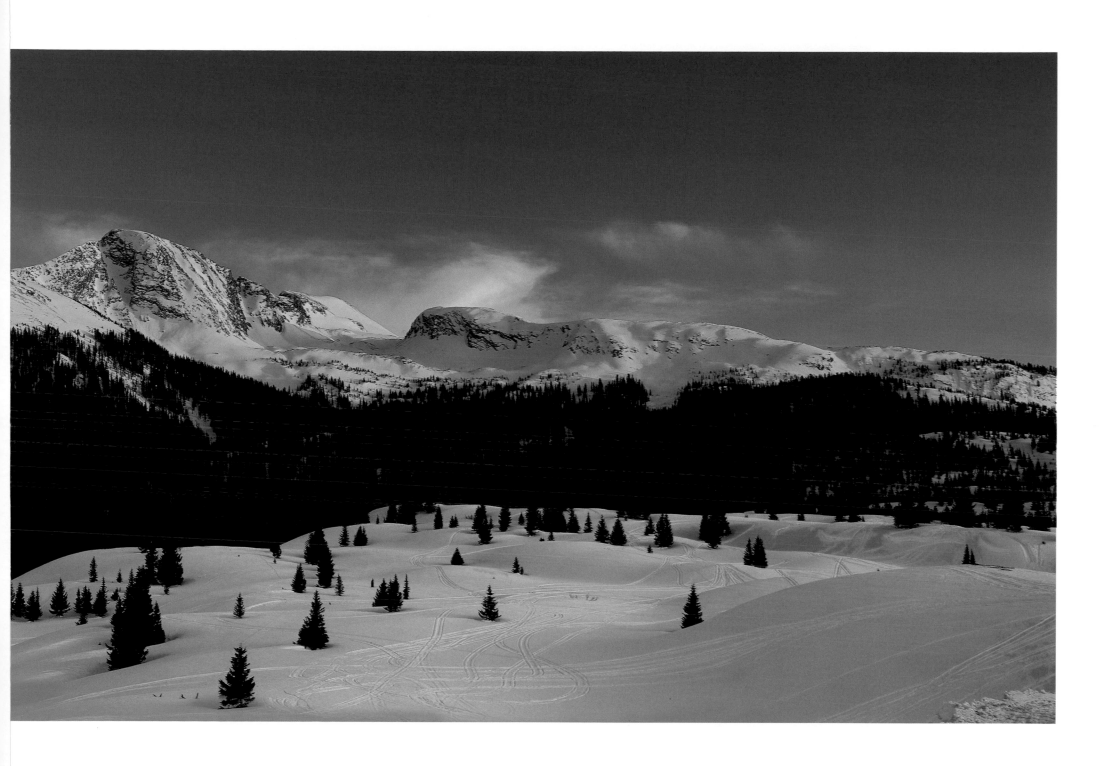

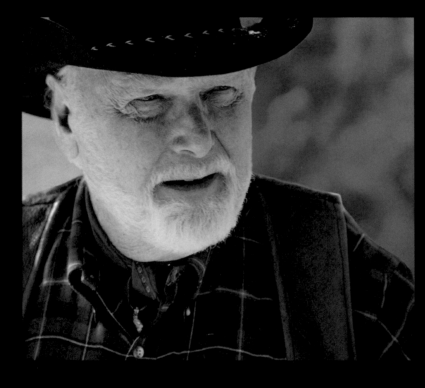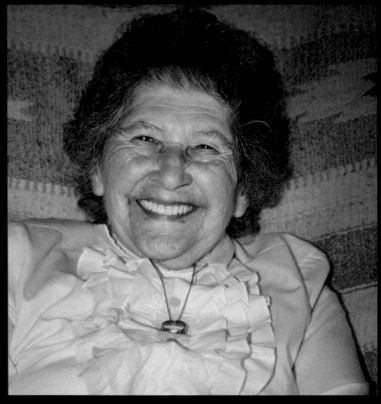

Harry Carey Jr.; Esther Montano

Ninety-year-old Esther Montano of Ouray, Colorado, can trace her family lineage back to land grants made to Sexto Martinez, her great-great-grandfather. "Those grants were made by the Viceroy of Mexico for land in New Mexico somewhere between 1735 and 1785, but they lost it. Lord knows why. My father felt they lost it because they thought they didn't have to pay taxes when the land came from Mexico." Esther's father worked in a livery stable, herded cattle and then helped operate a sawmill. In 1920 they moved to El Barro where Esther went to the camp school. "I told them I was in the sixth grade. They didn't believe me. They said, 'All the other girls your age are in the fourth grade' but I said, 'I can't help if they are stupid.'" "My husband and I met in McPhee, Colorado. He worked at the sawmill. The sawmill ran for twenty years, then they ran out of timber. We then moved to Dolores where he worked in a lot of little sawmills. Often he worked for the farmers. A lot of the time they didn't pay him with money but they paid him with food, which was what we needed. We moved to Ouray in 1950 because my son-in-law said there was work. He worked at the Idarado Mine. My husband ended up a crusher mechanic. They didn't think he could do it. They said, 'You know about as much about fixing a crusher as you do about making tortillas.' Frank got the job and he did it real well."

Harry Carey, Jr. moved to Durango, Colorado, in 1989, but his heart was captured by the "Wild West" from the time he was a young boy on his father's ranch. "It was that 'Old West' feeling that attracted me to Durango. I thought, boy, this is a nice place to live. And the people are so friendly. It reminds me of when I grew up in California, when I was a little guy and they still had horses tied up in front of the stores. You can sit here and look at these mountains and the air is marvelous. No rattlesnakes and no spiders. It's great! I was a fairly good cowboy. I knew how to rope, so I was very much at home in western movies. I have worked for some of the greatest film directors that ever lived...John Ford, Howard Hawks, and Raoul Walsh...and with John Wayne in eleven films," Harry states. "My father, Harry Carey, Sr., started making movies in 1908. He passed away fifty years ago, but he made hundreds of films." Harry, himself, has made almost one hundred western movies. Now he says that he wouldn't live anywhere else but in the San Juans. Harry even has a room named for him at the Rochester Hotel in Durango—the Harry Carey, Jr. Room. Harry muses that the motion picture business "has given me a fascinating life."

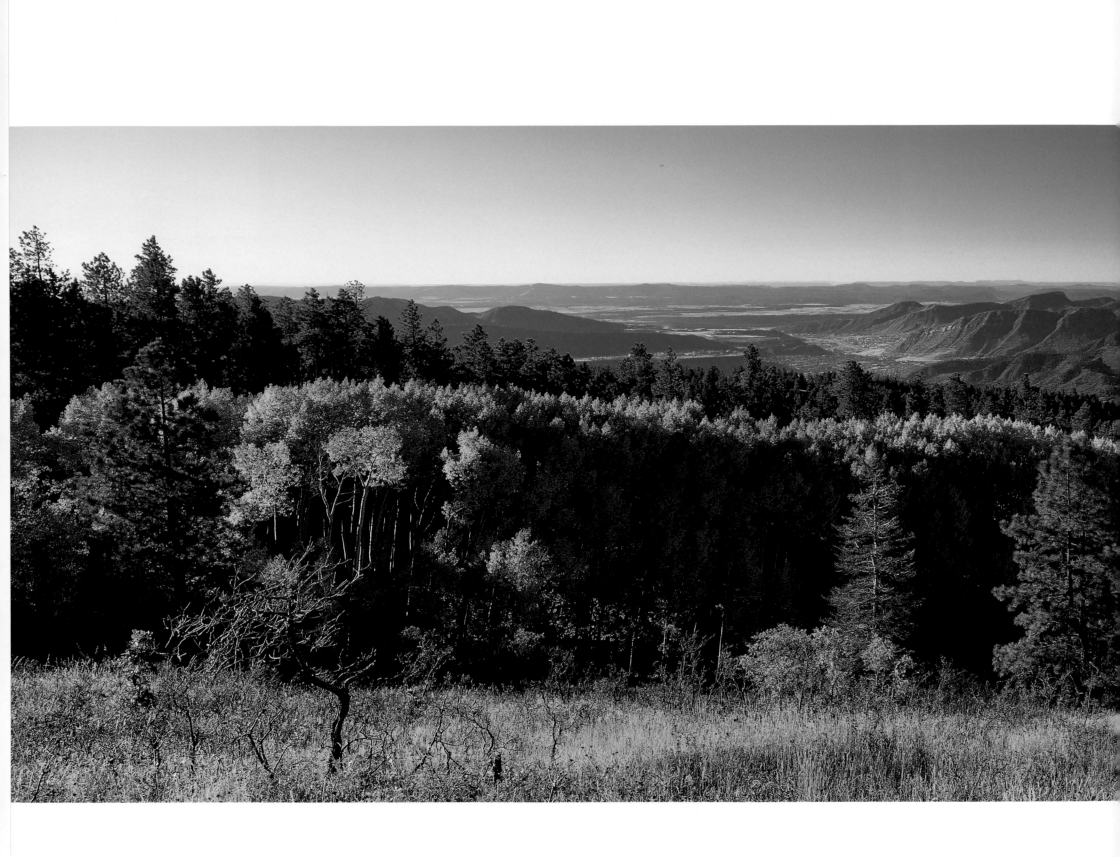

SPIRIT OF THE SAN JUANS

one hundred eighteen

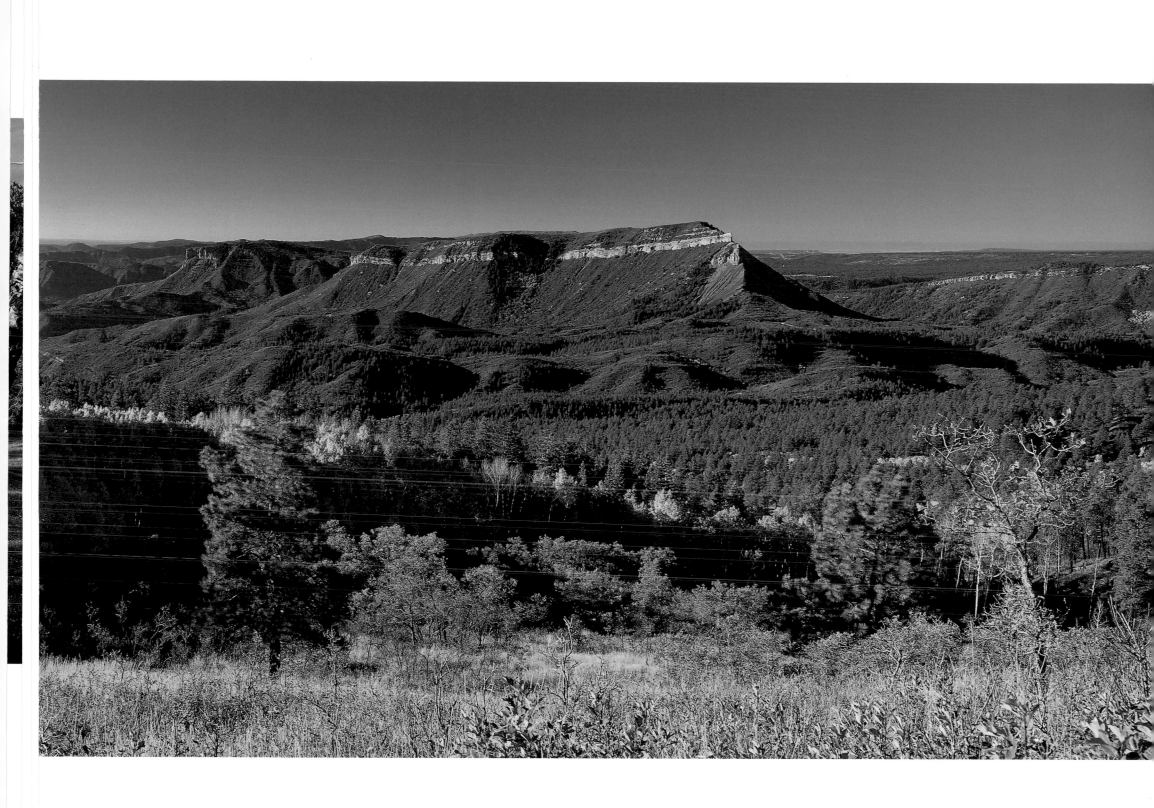

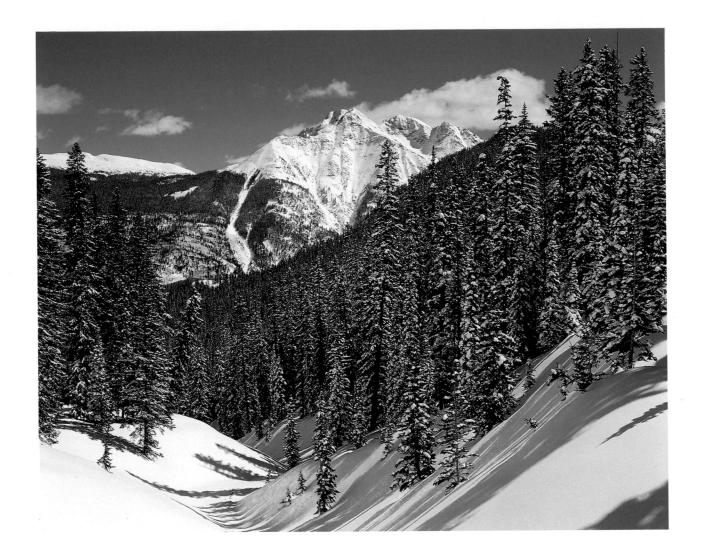

SPIRIT OF THE SAN JUANS

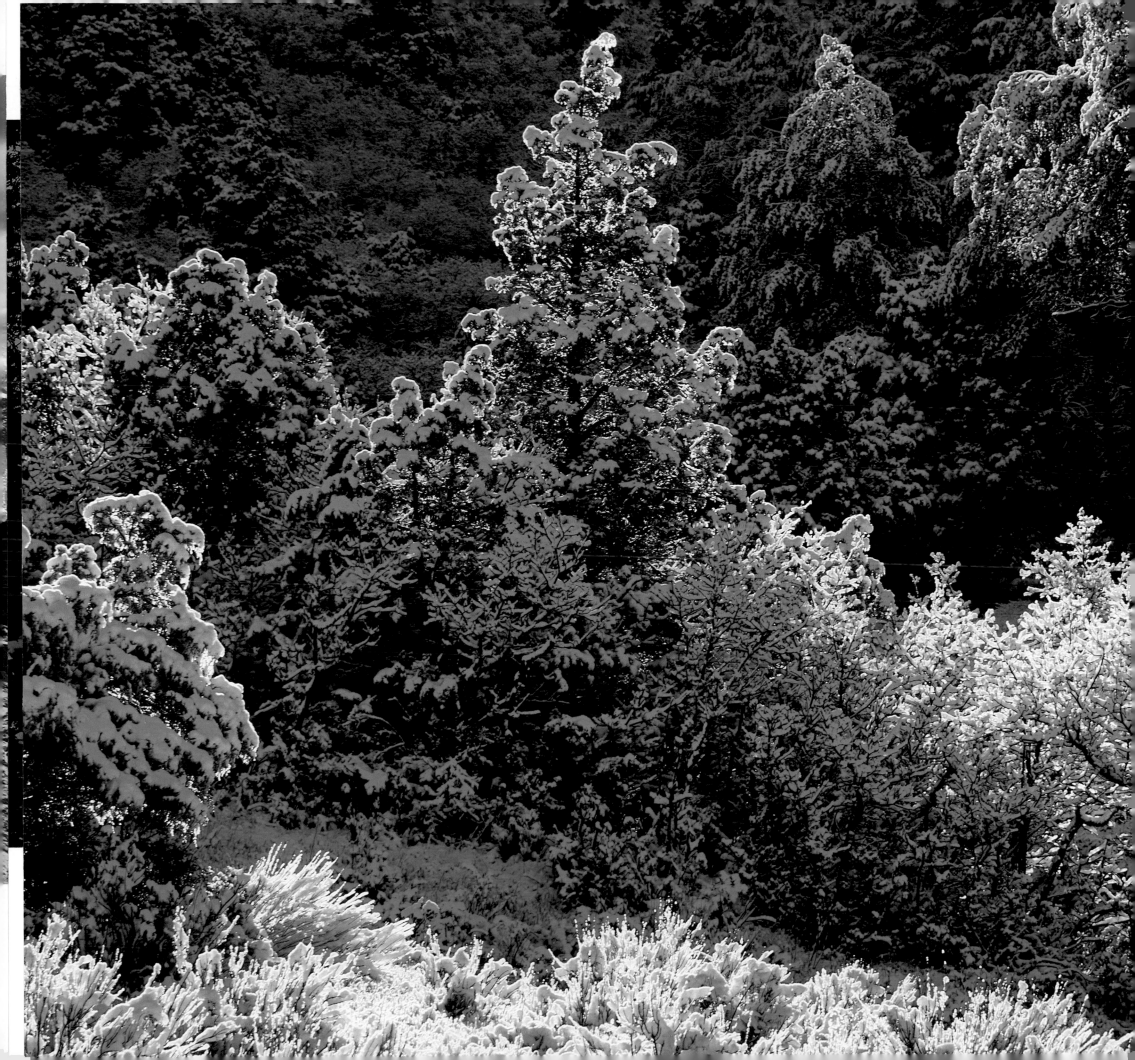

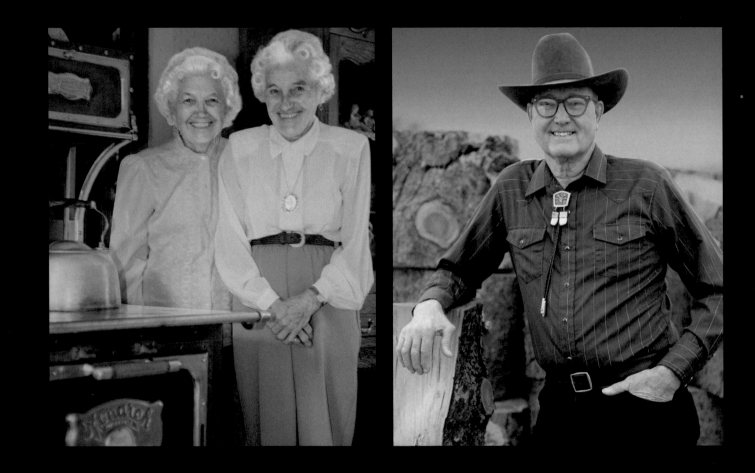

Irene Visintin and Elvira Wunderlich; Howard Greagor

"The Sisters" were born in Telluride and have called it home for all of their lives. Their parents immigrated from Tyrol (now Italy) and met and married in Telluride. The family's small house at Galena and Pine was destroyed by the Cornet Creek flood on July 27, 1914. Elvira married in 1936, and Irene and her mother moved next door in 1939. The sisters have lived next to each other ever since. Their woodburning stove was purchased for their mother when she was a young bride and is still used by them to make delicious baked goods. ∾ The sisters feel that it is acceptable that Telluride has changed radically, yet both regret that mining is gone. Elvira remarks, "If mining had stayed good, that would be different, but we needed something for the economy. People don't just come here. People go through Ouray and they have their hot springs pool. Silverton kept the railroad. But people don't come in just to look at the mountains and spend money. You have to have something for them. I guess skiing is the next best thing. If the ski area hadn't come we wouldn't be here. No one would be here." ∾ Elvira states, "Telluride is not an old person's town now. At this age we really should be going to a lower altitude. If I could take the mountains with me, I would go; but if I can't take my mountains with me, then I'm not leaving." Irene loves the San Juans also and says, "I feel free and protected by these mountains. These mountains feel a part of me. In the city, I feel like no one is watching over me. We love Telluride."

Howard Greager is a cowboy-turned-writer. "I was born in Placerville. My dad was a rancher on Beaver Mesa. Placerville was the biggest shipping point for cattle in the United States. My dad moved to Norwood in 1925. I was just one year old. My mother lived in the same house for sixty-three years. It's still sitting there. It's a good house." ∾ "All the time that I was growing up I spent with farm and ranch kids. Every time I had a chance I was on a horse. After I got out of high school it seemed natural to work for ranchers. Pay was $150 a month back in the forties. Betty and I were married in 1949, and it seemed cowboy work just wouldn't pay the bills. I went to Telluride and worked for the Idarado Mining Company. Norwood has always been agricultural, but it has also been a bedroom community for the people who worked in the mines. I was at the mine for fifteen years but weekends I was out here on the ranch helping move cattle. The Idarado shut down in 1978, so I went to work for Union Carbide in the Sunday Mine. I worked there four years and they shut down. Then I worked in the mill in Uravan for three months and they shut down. The last three jobs I had all closed down for mostly environmental reasons. You can't say that environmental control is not good, but it might be regulated a little differently to make allowances. ∾ "The San Juan Mountains were the place my dad grazed sheep. They were the place I would go for hunting. Now they are a place for winter sports. When you get too old to enjoy them any other way you can still sit here and look at these mountains. From Norwood it's 125 miles to a stop light. That suits me just fine."

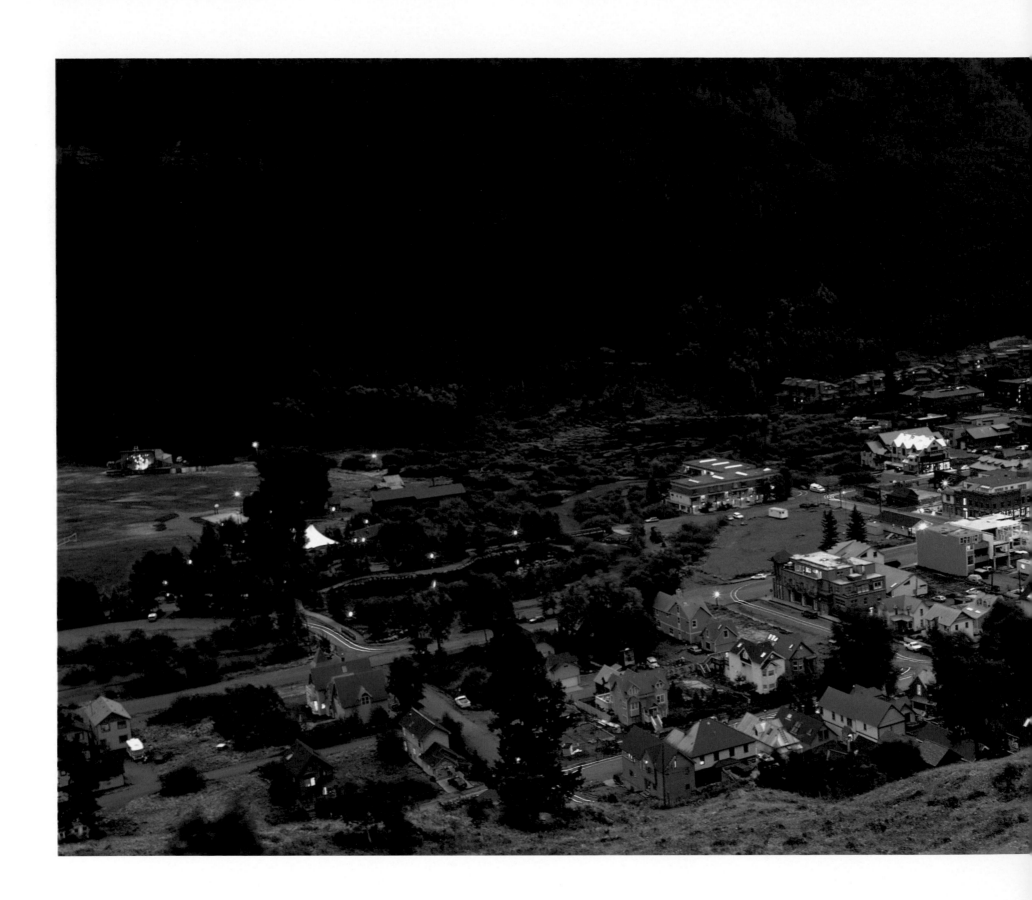

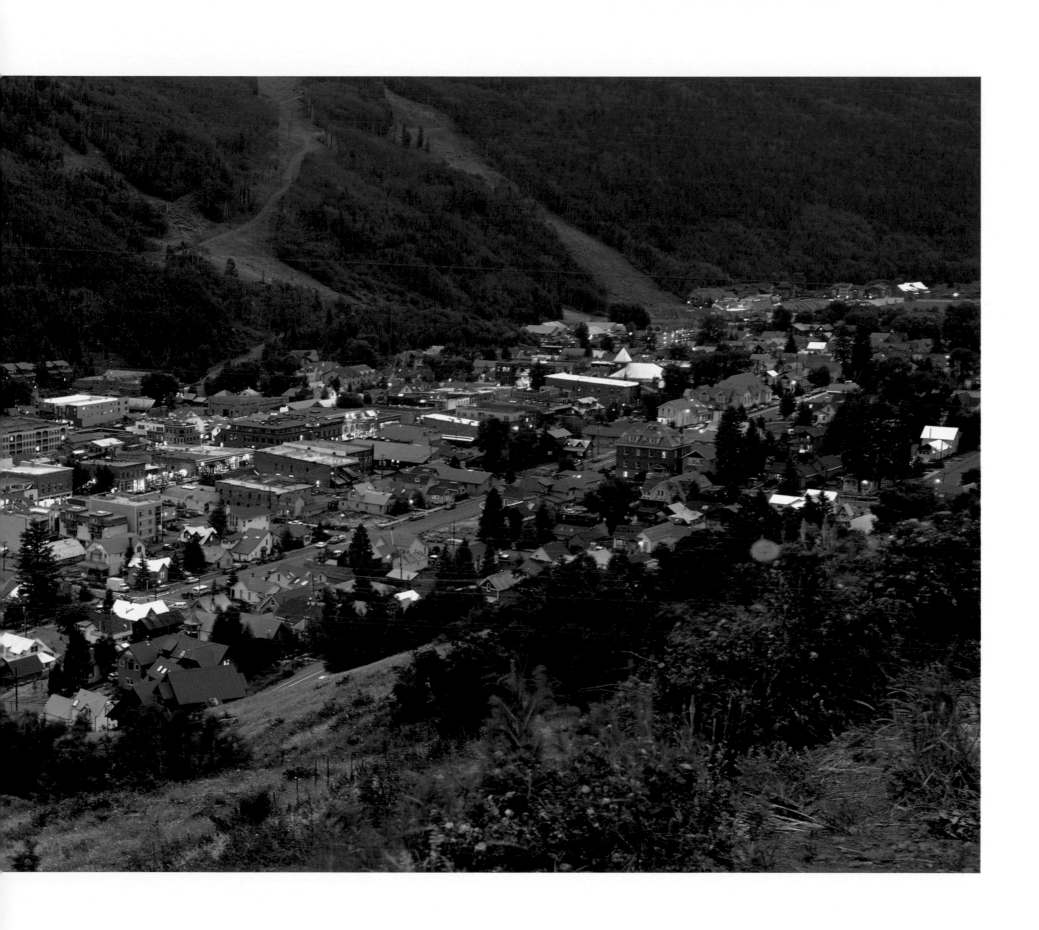

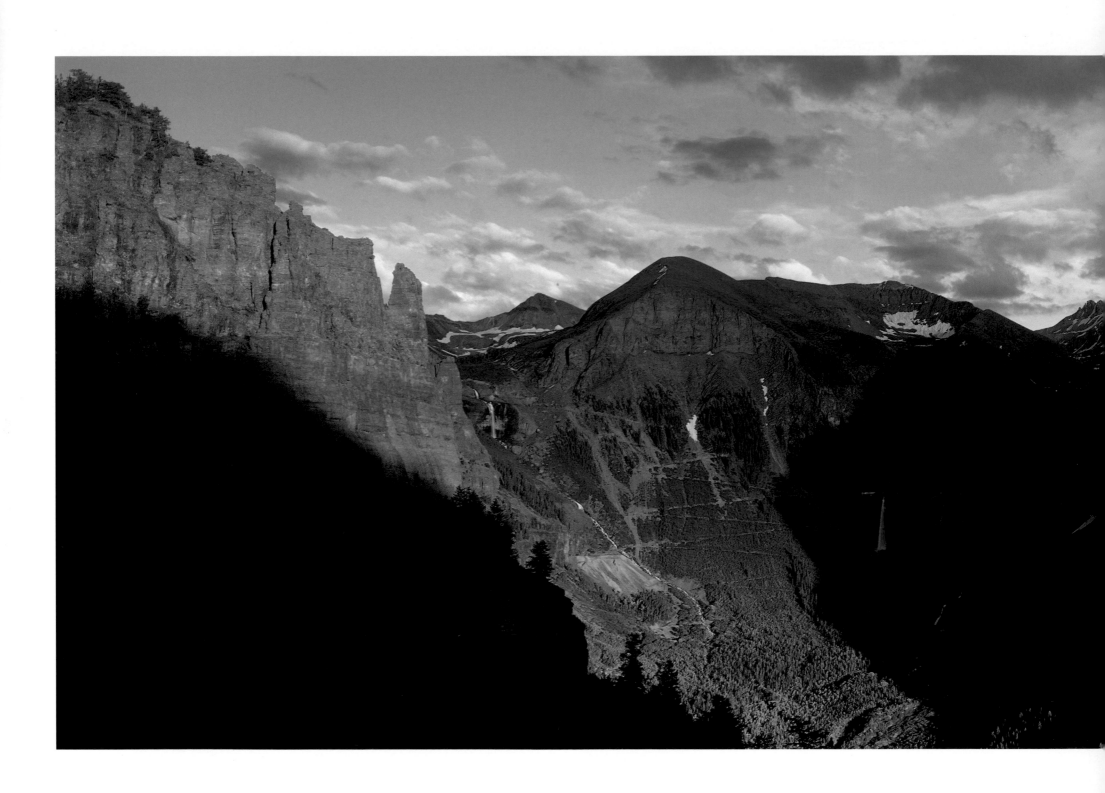

SPIRIT OF THE SAN JUANS

one hundred thirty-eight

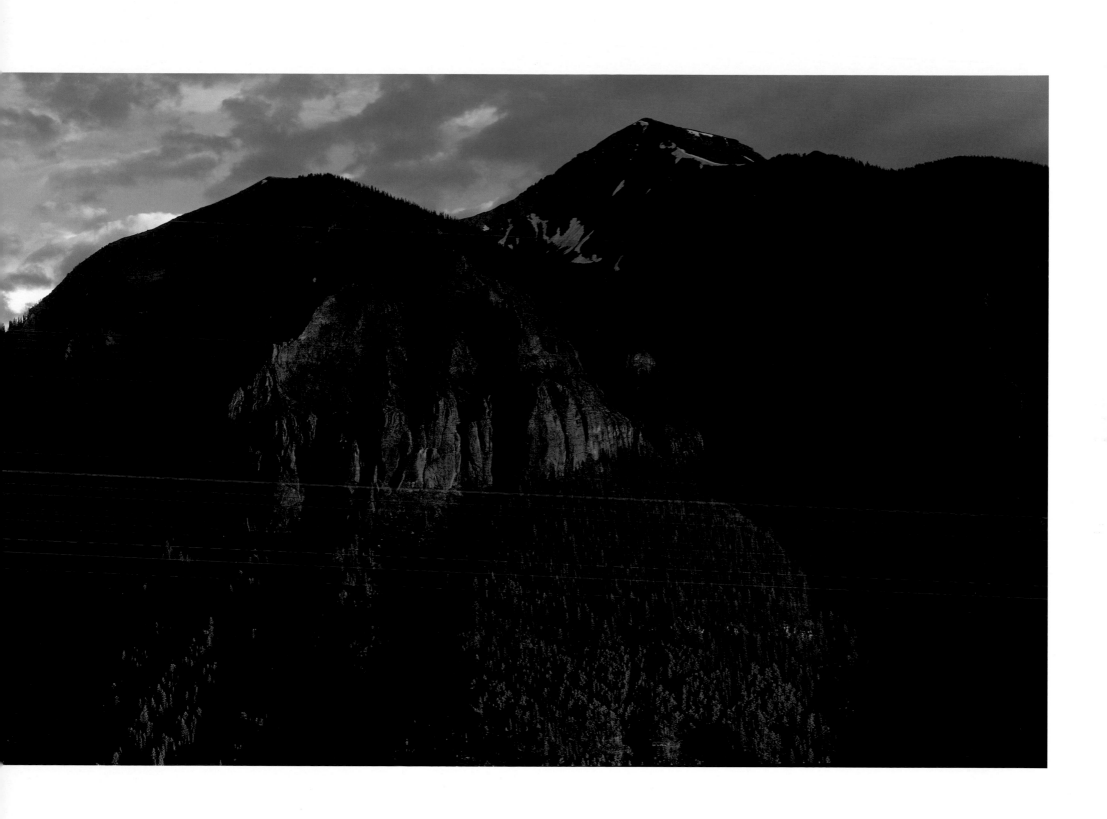

All the people of a country

have a direct interest in conservation...

Wildlife, water, forests, grasslands —

all are part of man's essential environment;

the conservation and effective use

of one is impossible except

as the others are also concerned.

—Rachel Carson

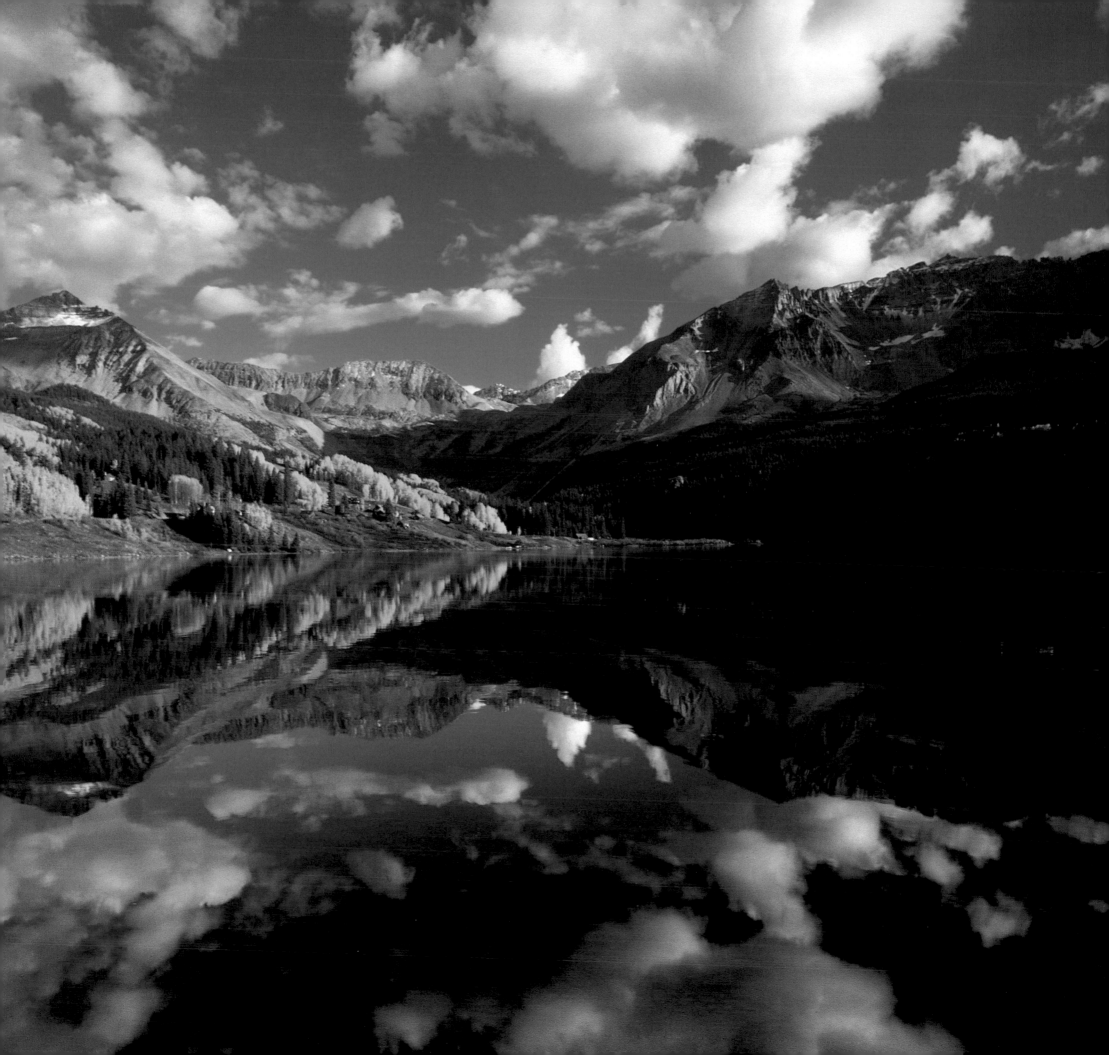

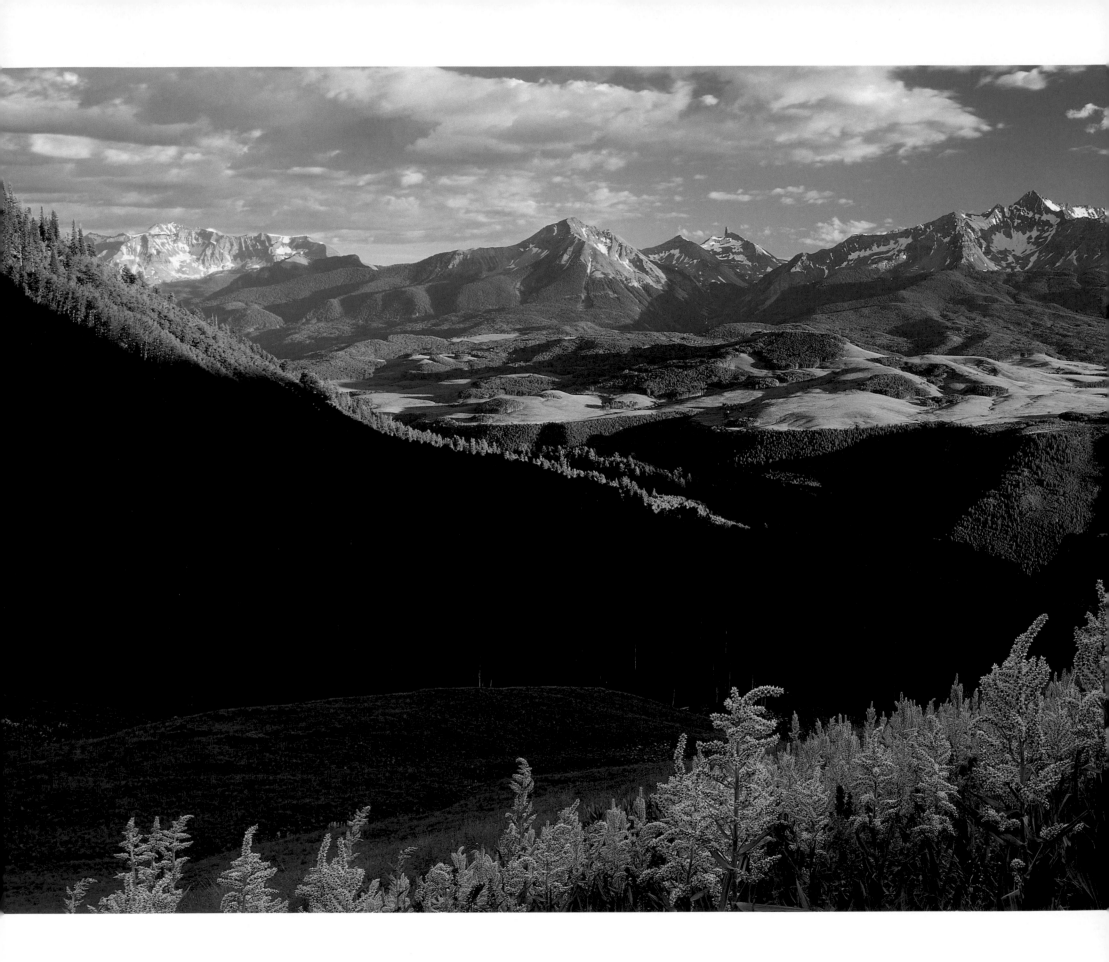

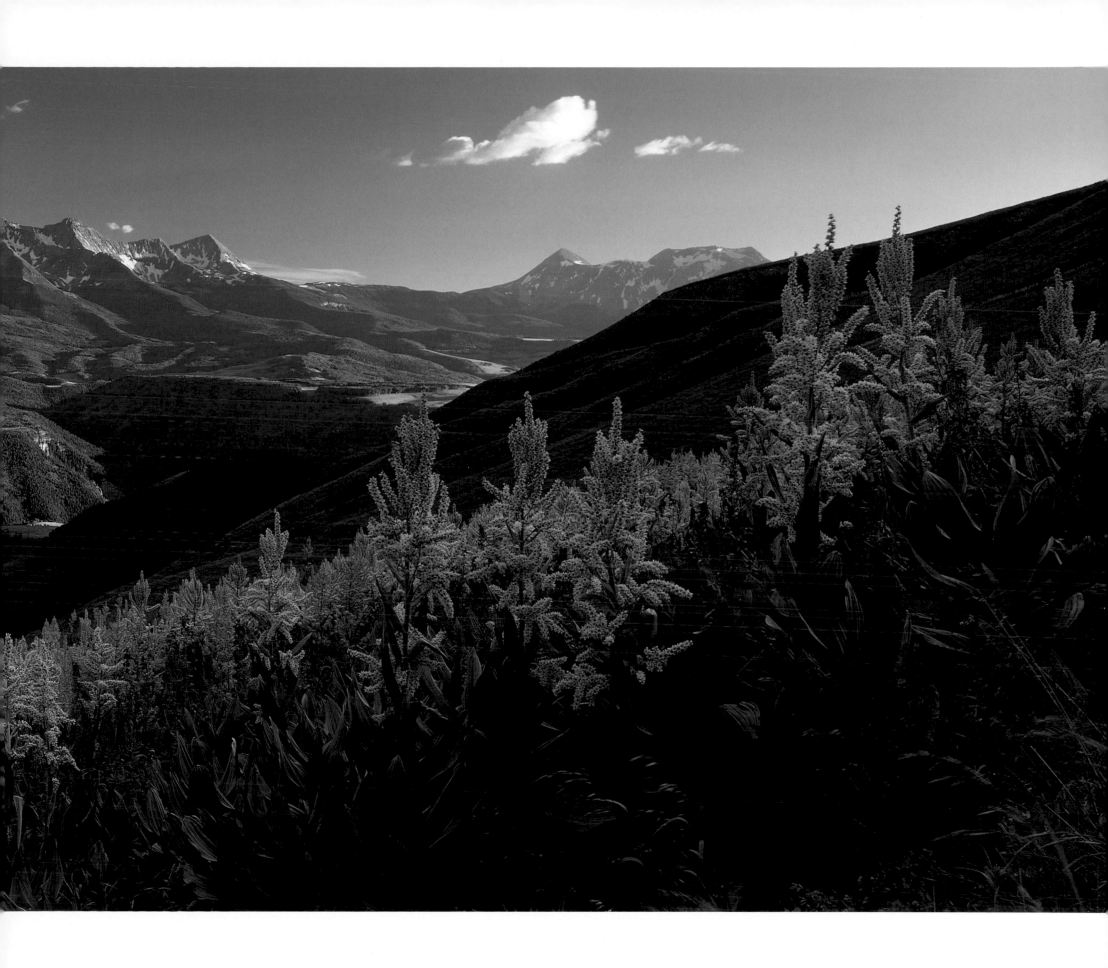

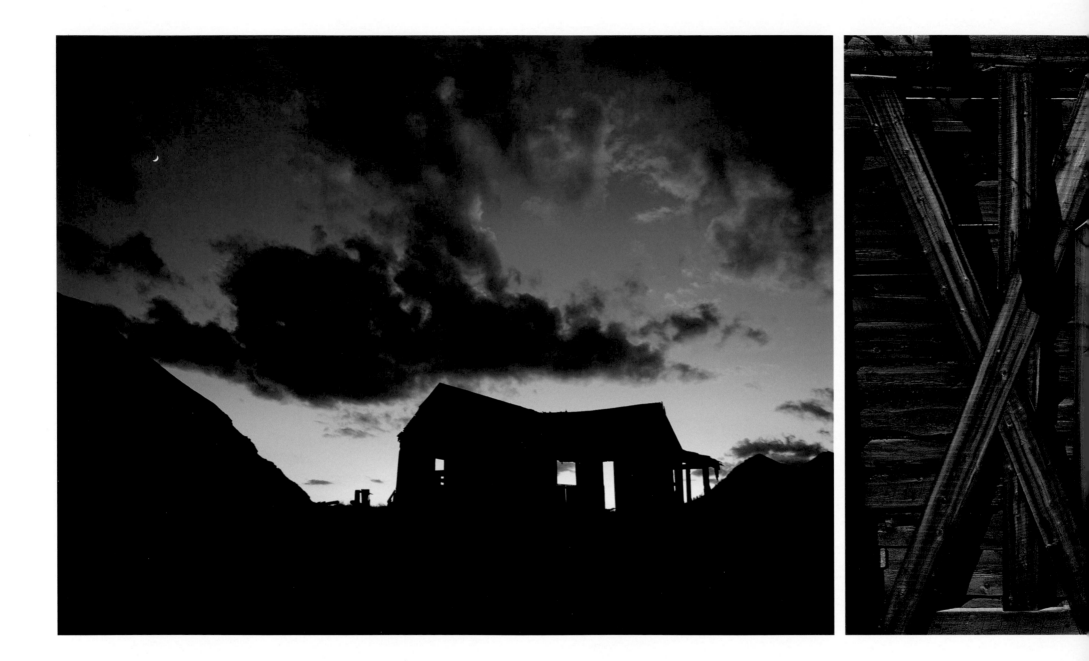

SPIRIT OF THE SAN JUANS

one hundred forty-four

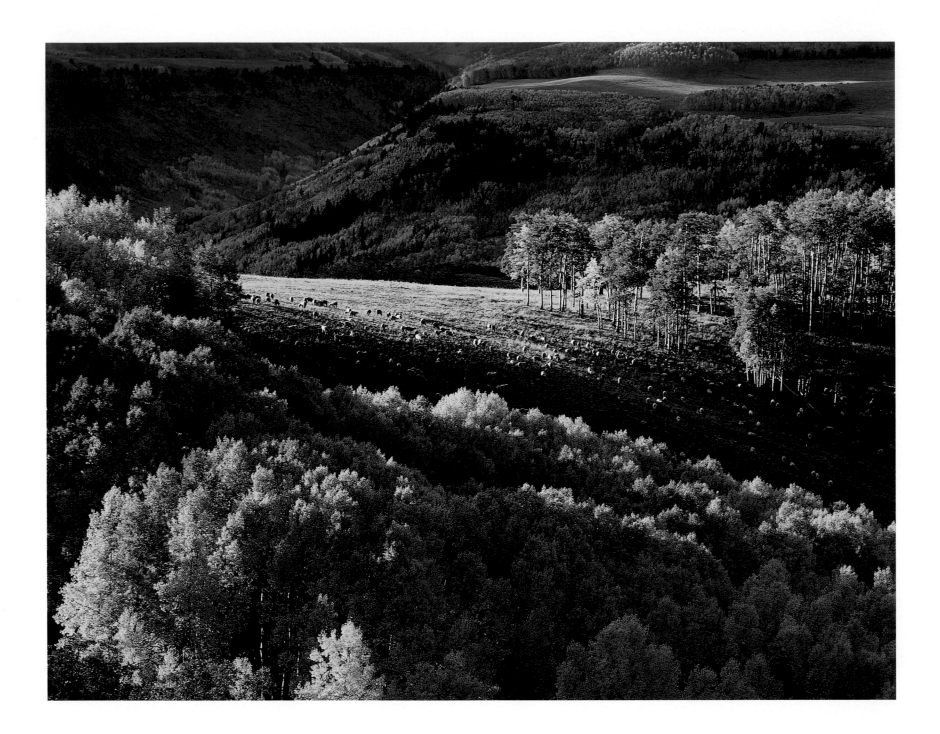

SPIRIT OF THE SAN JUANS

one hundred forty-six

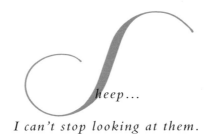

*S*heep…

I can't stop looking at them.

They're there, paralyzing the hillside

with thousands of mincing feet,

their bodies pressed together as they move,

saucerlike, scanning the earth

for a landing.

—GRETEL EHRLICH

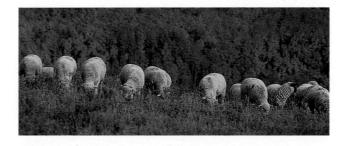

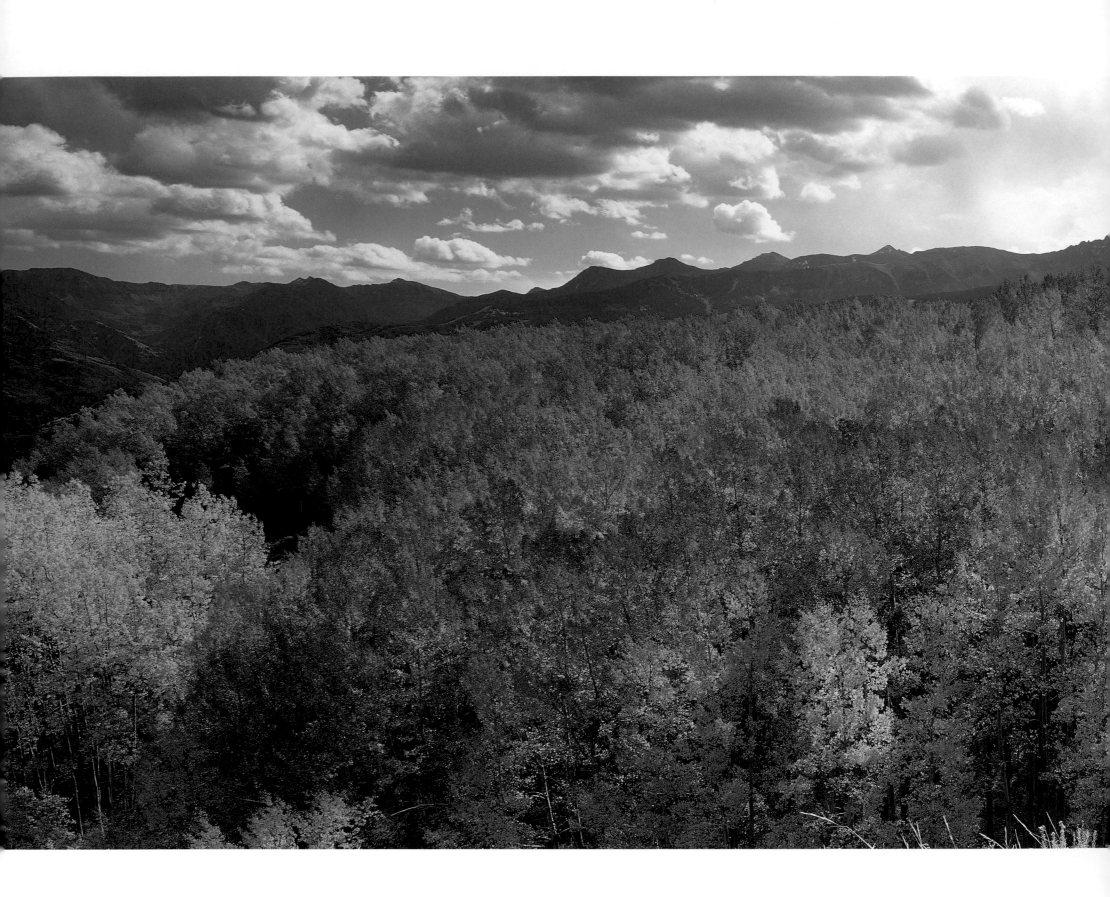

SPIRIT OF THE SAN JUANS

one hundred forty-eight

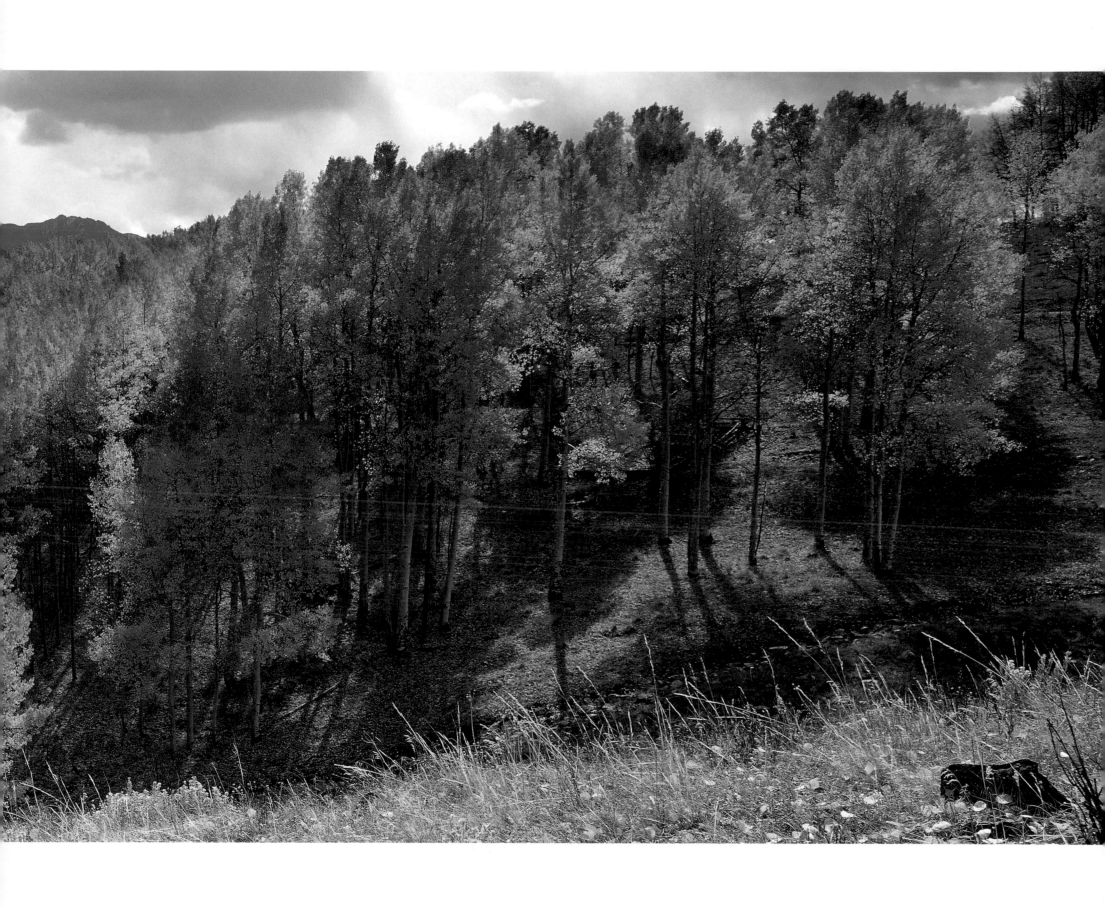

Autumn teaches us

that fruition is also death;

that ripeness is a form of decay.

The willows, having stood

for so long near water, begin to rust.

Leaves are verbs that conjugate the seasons.

—GRETEL EHRLICH

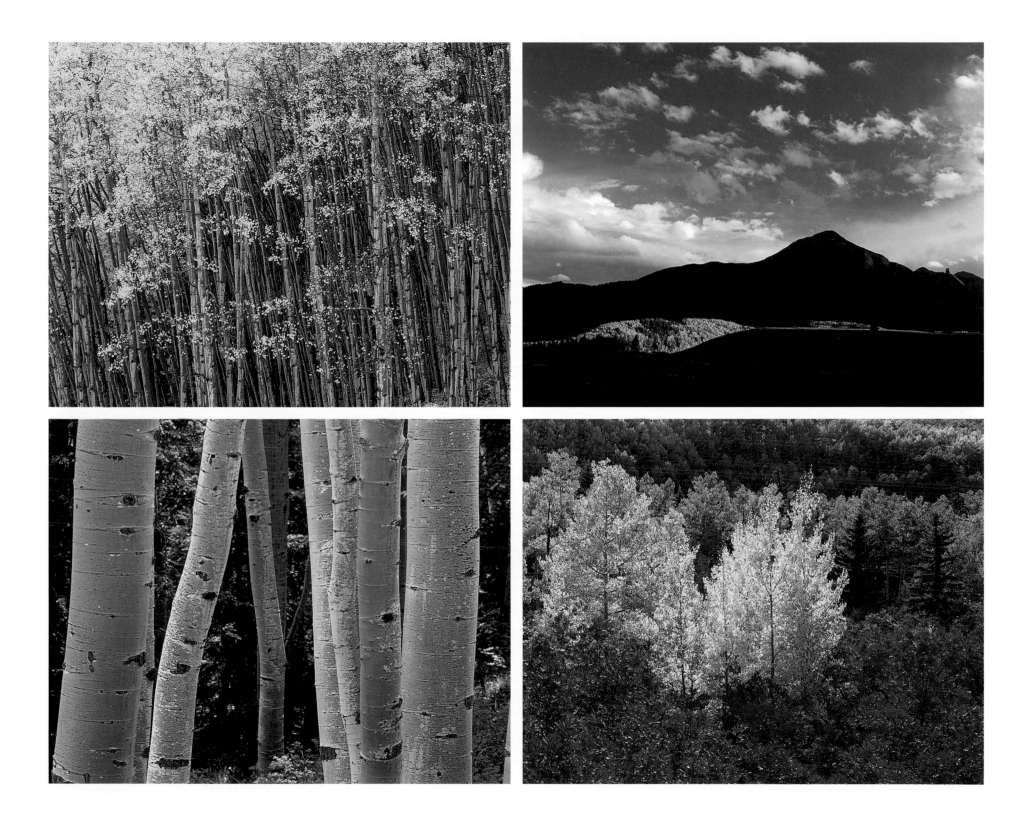

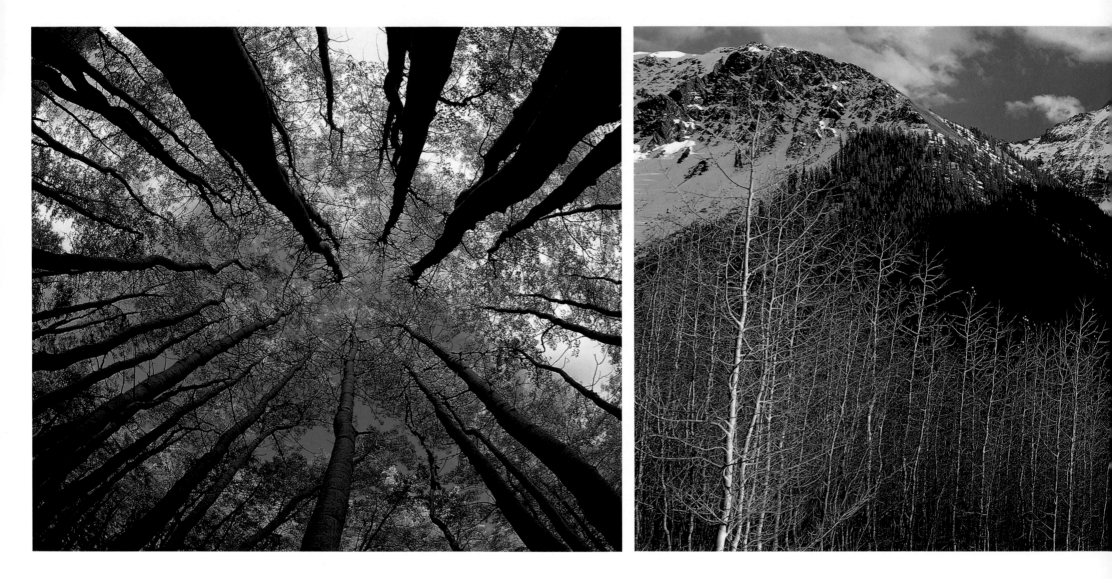

SPIRIT OF THE SAN JUANS

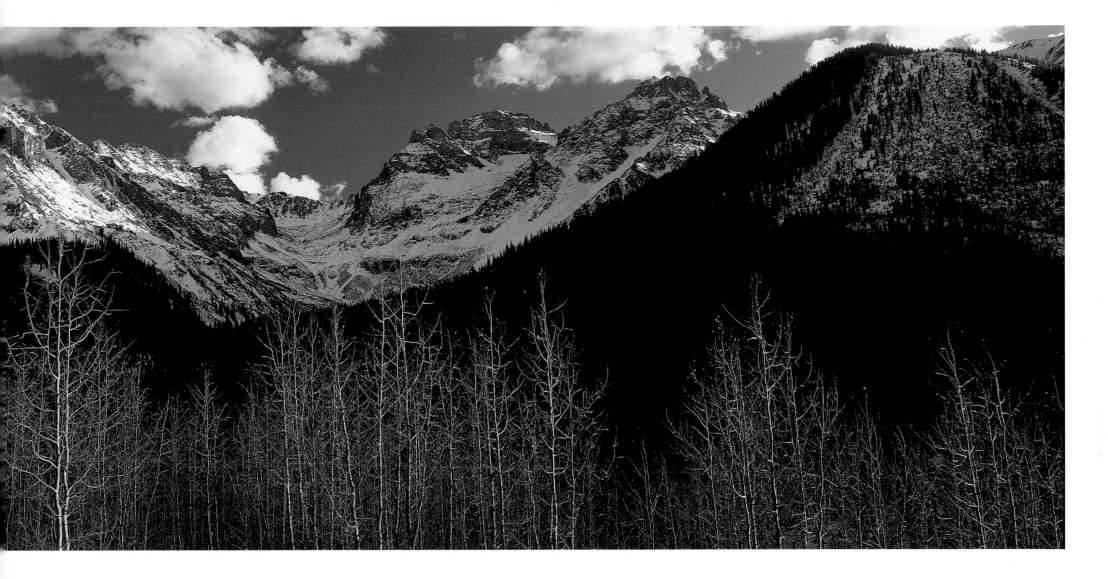

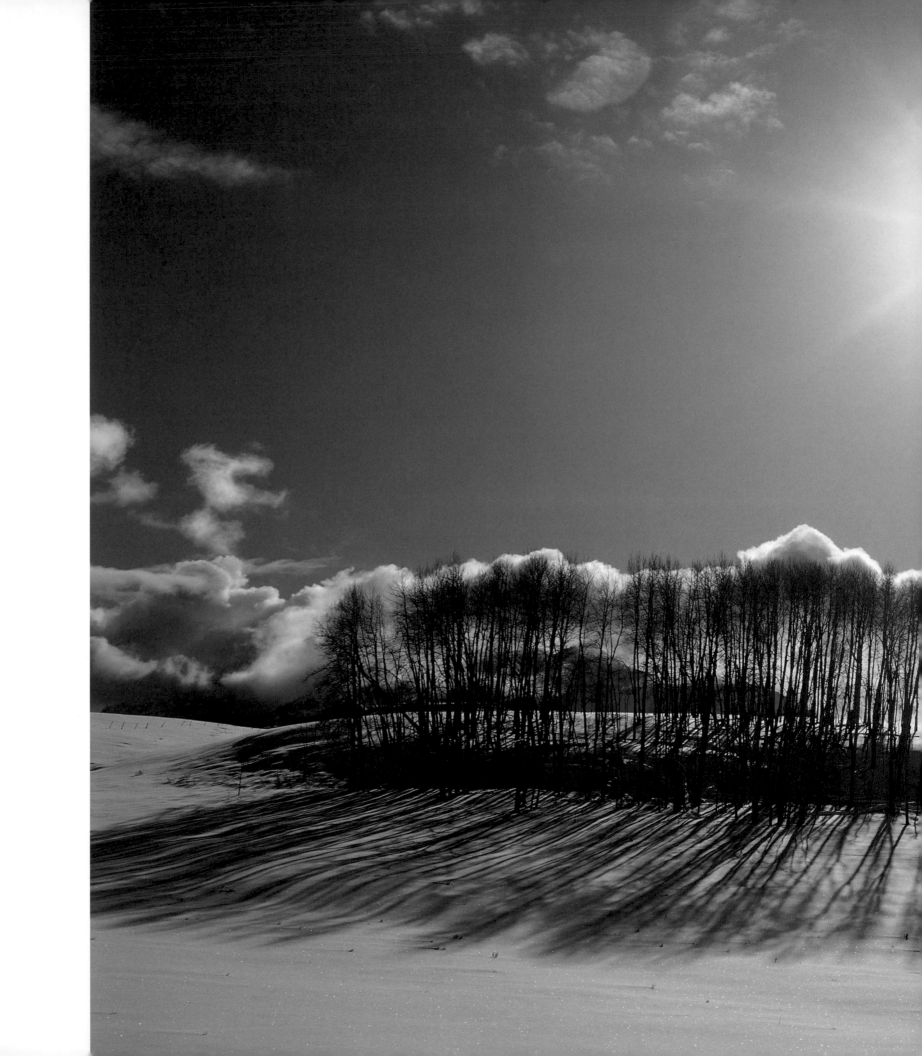

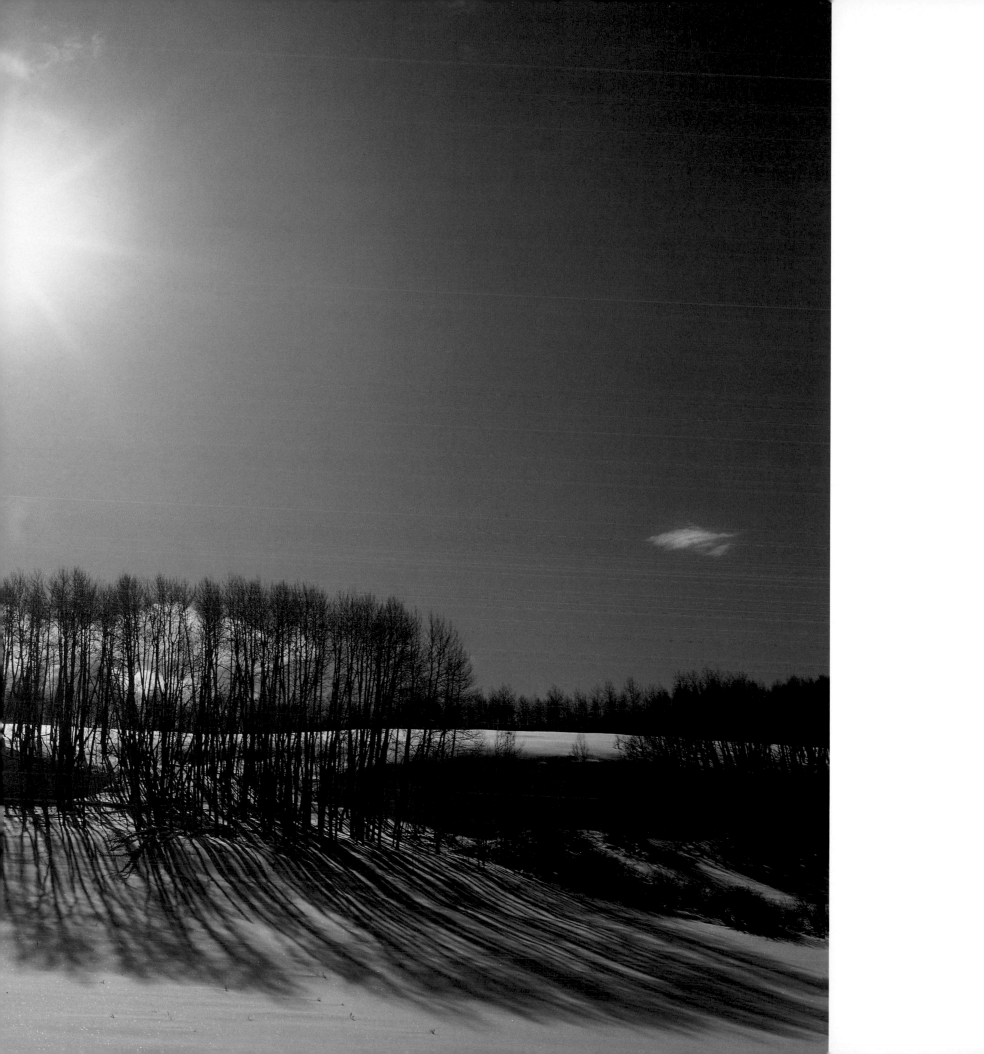

The same law

that shapes the earth-star

shapes the snow-star.

As surely as the petals of a flower are fixed,

each of these countless snow-stars

comes whirling to earth...

these glorious spangles,

the sweeping of heaven's floor.

—HENRY DAVID THOREAU

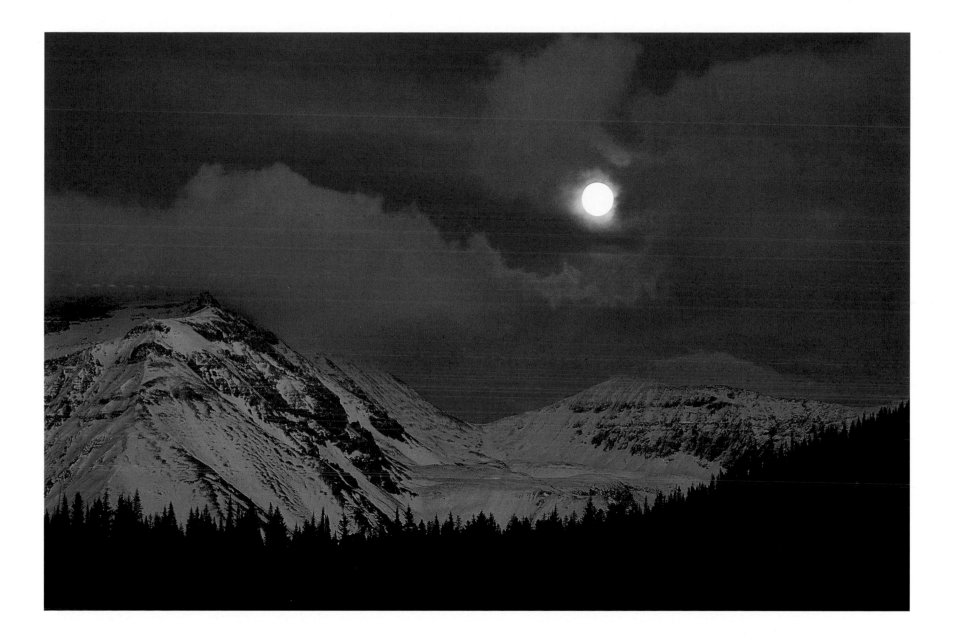

Index

PHOTOGRAPHIC NOTES

I deliberated whether to include technical data. Then I remembered how hungry I was to have whatever scraps of information I could glean from those photographers whom I admired. A few of the images were made in earlier years, while most of them are recent and a lot were shot primarily for this book. Consequently, for the landscapes there are two kinds of film—Kodak's EPR 64 Professional Ecktachrome 120 and Fuji's Velvia Professional 120 Fujichrome. The cameras I used were Asahi Pentax 6x7 with Asahi lenses (35mm through 300mm) along with a Linhof Technorama and Fuji's 617 Panorama. Processing was done by the Annex, A&I Labs in Los Angeles; special thanks, guys!

The portraits were shot on 120 roll film and 35mm—Kodak's T-max 100 and Ilford's 100. The cameras used were Pentax 6x7 and Nikon F4s and F5. The negatives were scanned at Res 60 for a 4x5 output, then digitally manipulated on a Macintosh Quadra 950. Additional cudos to the Bowhaus crew in Los Angeles (for scans) and to Main Street Photography in Montrose, Colorado.

The overview of Ouray, pages 48-49, is a horizontal merging of two images shot simultaneously with the 617 panoramic camera. To achieve the desired perspective, I realized that I couldn't get the whole scene in one shot. Therefore I chose to shoot it with the computer in mind as the final tool. With that exception, none of the other landscape images in the book were digitally enhanced or manipulated in any way. —K.N.C.

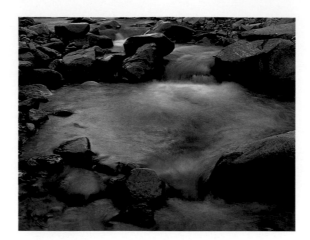

There isn't enough space to tell the stories behind the images in this book. If there were, then I would tell about the alpenglow I almost missed because I was looking the other way…amuse you by describing the time I photographed a fabulous sunset only to discover the lens cap was on…or chill you by describing the full moon, shot in minus 22 degrees with an ice-encrusted camera….These would be some of the stories, a few moments among many, some would be funny, some have been heartbreaks, but all of them were inspiring.

Most of the time I work alone. In my solitude, and especially during the beautiful moments, I often think of my Mother and wish she could be with me. For I am struck with wonder at my journey; how every moment happens only once, that it's the first and the last chance to experience it; it will never return. I am forever grateful to her for always telling me that I could be whatever I chose to be…I know she would enjoy the trip.

In 1979, the December issue of *Arizona Highways* magazine opened with one of my images and with it was the following quote. In its eloquent simplicity, it sums up how I have felt throughout my experience as a photographer. In closing, I would like to share it with you. —K.N.C.

My soul can find no staircase to Heaven
unless it be through earth's loveliness.
–Michelangelo Buonarroti
1475-1564

Production Notes:

Published by Western Reflections, Inc.

Design, production and typography by
Pat Wilson, Country Graphics
Text type, Cochin and Bembo

Introduction by P. David Smith

Separation, Printing and Bindery by American Book